A Retired Art Teacher Tells All

A KIND AND TENDER LOSS, A

A RETIRED ART TEACHER
Tells All

100 Simple Tips to Help Teachers Become Efficient, Inspiring, and Happy Educators

MARLENE NALL JOHNT

iUniverse, Inc.
New York Bloomington

A Retired Art Teacher Tells All
100 Simple Tips to Help Teachers Become
Efficient, Inspiring, and Happy Educators

iUniverse books may be ordered through booksellers or by contacting:

iUniverse
1663 Liberty Drive
Bloomington, IN 47403
www.iuniverse.com
1-800-Authors (1-800-288-4677)

ISBN: 978-1-4502-4976-8 (sc)
ISBN: 978-1-4502-4978-2 (dj)
ISBN: 978-1-4502-4977-5 (ebk)

Printed in the United States of America

iUniverse rev. date: 08/30/2010

Art and Self-Discipline

Joyous as it may be, the act of creating demands enormous self-discipline that teaches students to learn how to handle frustration and failure in pursuit of their idea. It requires setting goals, selecting a strategy, determining how to apply it, and continually making assessments and revisions – in other words, thinking and solving problems. It is the human mind operating at its very best.

—Charles B. Fowler, *Strong Arts, Strong Schools*

TABLE OF CONTENTS

Preface: My First Day as a Teacher

On my first day as a high school art teacher, I woke up in pitch-black dark. I carefully got dressed and drove my car over the Greater New Orleans Bridge and on for 30 more minutes to a large high school. Here, I met my carpool. Together, we drove for one more hour to Buras High School, close to the mouth of the Mississippi River. My first duty was ninth grade homeroom at 8:00. I am originally from Atmore, Alabama. I came from a world of *Adams*, *Deans*, and *Millers*; the final name on most lists was a *Young*. I looked out across the quiet, attentive room and I took a deep breath. The first name on my roll was *John Aucoin*: "John Akwin," I said. "John Auk coin? John Ack' in?" (Now, I can pronounce the short name correctly as *John Oh'quan*).

I am not exaggerating one bit when I tell you that I mispronounced *all 30* students' last names in that homeroom.

Just as I finished butchering *Michael Zerangue*, an office aid came to my door. "I have a new student for you in your English class. This is Mario Popich. He just came here from Yugoslavia. You'll teach him English."

In a pathetic voice, I responded, "Thank you."

1

I led Mario to a place to sit. I walked back to my desk where another student was now standing. He looked like he wanted to ask me a private question, so I moved to sit down waiting to hear whatever it was. It never came. Instead, he yanked my chair out from under me and I hit the floor amid shouts of laughter. As I came to my feet with great clumsiness in my new shoes on the slick linoleum, it dawned on me that the sweet little quiet blond student sitting *directly* in front of me was the principal's daughter.

Standing there, I faced the dilemma that haunts all teachers: *how do I respond?* Do I yell at the young man who pulled out my chair or keep it to myself because I do not want the principal to find out I cannot control my class? His daughter will certainly tell him all about it. Do I cry and run out of the room hoping that I will receive sympathy from the students when I return? Do I take him to the office and let them handle this one because of the seriousness of the act? As I debated, I looked up at the clock at the back of the room horrified to discover that *it was only 8:15.* How would I be able to teach for 20 to 30 years!

I went into teaching for the same three reasons that Dr. Joe Martin listed in the survey he did for *Education Week* magazine (as reported by CNN): I wanted to make a difference; I believed in the potential of my students; and I derived an immense amount of joy and satisfaction from working with students. I knew all of this when I signed my contract with Buras High School. I clung tightly to these ideas even when the principal taking my newly signed contract casually let drop, "Oh, did I mention, Marlene, that you will also be teaching one remedial ninth grade English class?" I knew and yet that first day of teaching nearly undid me.

Every teacher needs to have a *very clear and firm understanding of how she will manage her classroom.* This will contribute to whether

a teacher will enjoy a rewarding career in teaching or become one of the 48% of teachers who quit in the first five years.

But I did not quit and become a statistic.

Instead, I marched the young man responsible for dumping me onto the classroom floor straight down to the principal's office. When I returned to the class, I explained that the principal was handling the matter and asked if anyone else would like to join the young man in the office? They got the idea. Now, 23 years later, I know that I should have sent another student to get an administrator, or called the office on the intercom rather than leaving the other students unattended. A rookie mistake, but I lived to teach another day. And so will you.

ACKNOWLEDGEMENTS

To my mother, Mildred, daughter, Alaina, and my vast extended family, thank you for sharing your love and humorous approaches to life, as well as your unwavering encouragement and enthusiasm.

Jim, thank you for spending a year doing nightly editing and challenging me to clarify my thoughts. Without your loving support, patience and faith, I could not have written this book. Truly.

Janice, without your technical expertise this book would not have made it to the publisher. Patience is your virtue. Thanks for burning the midnight oil.

Robin Lee Mozer, when the tunnel darkened and I couldn't get this book finished, you saved me by using your first rate publishing skills to complete the project. Thank you, Robin.

I thank all my professors, principals, and fellow teachers, who modeled exemplary teaching habits to me over the years and who

shared joys and tears. A special thank you goes to Dr. Margaret Ryan, University of Southern Mississippi, who drilled into me the importance of organizing my thoughts and for writing clearly.

To all of my student teachers, who over the years generously shared with me new methods and ideas learned during their college experiences, thank you. Working with each of you brightened my own teaching. You added heavy doses of creativity and fun into the students' art experiences.

To all of my students, thank you for giving me such marvelous material to work with. Each of you affected me with your unique outlooks on life and learning. You enriched my life by sharing your world with me. I know you will remember my Friday advice: "And remember students, make wise decisions this weekend. A lot can go wrong in the blink of an eye!" I dedicate this book to you in hopes that I helped you learn how to make those hard, wise decisions in your adult lives.

Introduction: How to Use This Book

I am suspicious of people who have not suffered a little while learning to be a good teacher. For example, let us consider one imaginary Algebra teacher. Have you ever heard students talk about a brilliant math teacher who cannot seem to get the concepts taught? Grasping formulas came easily to this teacher when she was learning. She just does not seem to be able to break down the information for the "math challenged" student and she will not try new approaches. She is an old piece of coal.

Only pressure can turn coal into a diamond. Additional pressure cuts and shapes the diamond into a thing of unparalleled beauty. Teachers get better with pressure, too. Bless those "mine owners," the administrators, who, with their fingers crossed, hire new teachers. They hope the piece of coal will become a diamond one day.

You will, undoubtedly, face your own pressures and challenges. As an experienced teacher, whenever I would turn over a class to a new student teacher, I witnessed these struggles over and over. I had to fight the urge to bulldoze my way in and take over. Everyone learns to teach by doing, but honestly, it can be painful to watch. Most painful, perhaps, because I know their deepest, darkest fears.

When I decided to become a teacher, I wasn't thinking about my first day. Instead, I was imagining how my future students would remember me at their ten year high school reunions. I could visualize my protégés in their party clothes, reminiscing about what they got out of my art class: the cool projects they did, liking the art room environment, making new friends, having their work displayed publicly, winning awards, or going to college to make a good living in an artistic career.

What I did *not* want to be remembered for was being a teacher who was a pushover. I *did not* want my students to remember me as a teacher with low artistic standards. I *did not* want them to remember me as a teacher they made cry, or one who yelled all the time. Who wants students to remember *your* class as being used as a study hall or the class where everyone gossiped? Who wants students to remember you as being insignificant or an out of touch joke? What if you were remembered for having fewer skills in art than many of the students you taught? The worst thing, for me, would be students remembering me as a teacher who never tapped the deep talent of her students because I never seemed to "get it together."

What This Book *Is*

So many of the books I eagerly read as a young and anxious art teacher let me down. They intimidated me with all of their pretentious verbiage, and all seemed to deal with either processes and projects, or very heavy journal studies. As a new teacher, I wanted advice on the *human contact* issues. Several books I read on teaching art made me feel like I was reading an art-teaching autopsy! I decided then that if I were ever to write a book for new teachers, I wanted to write a book that did not include a recipe for making paper mache. I wanted to write a book that never

once used the word "pedagogy." (If you do not already know what pedagogy means, look it up. Here is a hint—you are about to dive right into it.)

This book is designed to help build an art teacher's self-confidence in the classroom. In it, I offer suggestions on ways to make teens *fight* for the opportunity to get into classes to learn art. I also hope to show teachers that it *is* possible to be showered with affection and praise from former students *without* being a pushover.

How This Book Is Designed

A Retired Art Teacher Tells All is organized into eight chapters, each of which offers Tips, which I've grouped by topic. I chose a dropped capital letter as a standard format to announce each Tip. I use it to bring attention to an important issue. Under the Tip, I elaborate with examples and suggestions on how to implement it in your classroom.

For some of the Tips, I have included Thought Provoking Questions, and for some, I have also given a few Examples. As teachers, we sometimes benefit from self-questioning our beliefs and motives. The Thought Provoking Questions included here are personal questions intended for serious reflection. I hope you will not rush through them, as one can learn much about one's attitudes and beliefs by pausing and thoughtfully writing down what one believes. In addition to describing for you the perfect perceived outcome for using these Tips, I will also paint for you examples of what can happen if you choose to ignore a given Tip. Many of these examples come from my own student teachers, who learned quickly from mistakes. You will see through these true examples some pitfalls that you may never have considered, and hopefully why some shortcuts just must not be taken.

Who Should Use This Book

Art class is, essentially, lab teaching. I know this book will help anyone teaching in a lab situation such as marine biology, band, chorus, chemistry, family and consumer sciences, earth science, industrial arts and drama. My Tips easily apply to classes with money issues, supply issues, storage issues, issues surrounding movement of students during class, and issues that arise while teaching students of varying abilities.

Overall, I hope readers use this book almost like a daily guide. In writing it, I've tried to incorporate the style of other classic advice books like *Simple Abundance*, by Sarah Ban Breathnach, a book that challenges the way readers view and then choose to live their lives. Ban Breathnach offers a quote for each day and then embellishes it with ways readers can apply the quote to their own lives. Like Ban Breathnach, I have tried to offer a simple truth about teaching, then an embellishment. Occasionally, though, you may read something in these pages that reminds you more of Dr. Phil McGraw; his "get real" voice peaks out a bit in some of my tips to art teachers.

Each art teacher must be comfortable with his or her own teaching philosophies. Individual philosophies are what make each classroom unique. Just as each student's art project should show confidence in its original interpretation within the given restraints, so, too, should an art teacher's teaching style show confidence, thought, and originality. So regardless of whose voice you imagine when reading, I hope you will give serious thought to the logic I present in these pages, and that you find it valuable for creating your *own* teaching style.

Chapter 1: Starting the Term

Tip 1: Create a List of Questions for Your Principal

F ind out what you will be teaching, how many students you can expect to teach, what room(s) are you in, names of contact people, and any money issues involved with your classes.

If you've been hired at the last minute, you might have accepted a teaching position before you have even seen the room you will be teaching. In general, though, the following questions will be answered in a departmental meeting, a new teacher seminar, or a general faculty meeting before the school term begins.

1. How many students can I expect to teach? What administrator has this information?
2. Will the courses last one half year or a whole year?
3. What grade levels will I teach?
4. Are there mixed grade levels in your classes?
5. Is there an art fee to be collected?
6. How is the art fee to be collected and by whom?
7. If I collect the fee, to whom do I turn it in and who will explain the procedures for collecting these fees?
8. How much money is there available for me to spend *now* and who is the person I can get this information from?
9. Is there state and federal money available for me to spend on supplies other than from Student Fees? Who is in charge of this account?
10. Where are all the art supplies stored now?
11. Whom will I work with to get and process purchase orders for art supplies?

12. Will students be sitting at tables, individual desks, or drafting tables?
13. Is there a sink or sinks in the art room? Do they have clay traps in the drains?
14. How much storage will I have and where is it in the art room?
15. Will I share the art room with another art teacher or another academic teacher?
16. Will I have a homeroom?
17. What are my duty assignments? Who is in charge of duty assignments? How will I get hand soap, trash bags and paper towels? Who is in charge of maintaining the art room?
18. What principal will I be working with regarding discipline?
19. What administrator may change student schedules after school starts?
20. Each day, how will I communicate attendance records to the office?
21. How long is the class period?

Do not ask for more than 15 minutes of the principal's time if you are still unclear about the above topics. Do not stay longer unless he or she asks you to stay longer. Do not be surprised if he or she passes your questions on to someone else.

Of course, if you have already seen your new room, you will already have many of these answers. *Keep the answers to these questions handy at our desk.* You may very well be feeling overwhelmed now. Do not worry. As you read on you will digest it and it will make sense.

Tip 2: Create the Right Classroom Environment

I *f you carefully plan the first days of school, you will set a solid foundation for the day-to-day operations of the entire term.*

Two important considerations in any classroom are adequate seating and a visually stimulating room. I make sure all tables and chairs are clean and inviting. For many students, at first, the art room might be a scary place. Try to make it as friendly as possible. I count chairs and make sure there is room for each student. I check this against the class roster that has the largest number of students. It can be embarrassing for a child to stand and wait while you obtain for him a chair from another room.

Also, make sure you have a variety of styles and periods of art displayed around the room. For instance, I have examples of Impressionism, Expressionism, Non-Objectivism, and Realism placed on my walls. These pictures stay up all year. I have examples of architecture, additive sculpture, and subtractive sculpture displayed on high shelves. The sculptures also stay up all year. I display collections of excellent works created by former students. These works are to inspire my new students. I display a wide variety of styles and techniques. I make sure none of the work is falling down. Although on the first day I do not discuss all this displayed work, I certainly want it to help set the mood for our learning environment.

The day before you meet your students, be sure to have the following:

1. A supply box on each table filled with pencils and erasers (see Tip 32);

2. Your classroom rules posted in a prominent area (see Tip 16);

3. Five different punish-work assignments, each in a zip-lock bag (see Tip 17);

4. Printouts of class rolls of all students by class period, laid out in order;

5. Enough paper for a drawing assignment;

6. A "worst case scenario" plan for discipline (see Tip 17);

7. Examples of some of the projects the students will do during the course (see Tip 5);

8. Arrange student tables or desks (see Tip 24).

If you have prepared all of the above, you certainly will be able to handle your first day with grace, confidence, and humor.

Look around your art room. What would you think about coming into this room every day if you were a new student? What changes can you make? What changes would you like to make later, down the road? How does the room reinforce who *you* are, their new teacher?

Write down your observations and plans for changes below:

Tip 3: Mix Up Activities the First Week in Beginning Art

I n your *Introduction to Art or Art 1 classes, mix up the first week by having drawing activities, organizational duties, and student and teacher introduction.*

My classes were 96 minutes each and, oh, let me tell you, this time can be an eternity if one is not flexible with different activities. You will need 10 minutes to start class and 10 minutes to clean up, so shorter classes have less interacting time. I loved the long block-scheduled classes because of the longer uninterrupted creative time. You may need more days for your first week activities depending on class length.

Please be flexible, after all, who knows when there will be a tornado drill or an emergency call from the Yearbook staff for a full class picture. Did I mention be flexible? *Be flexible!* You will not be able to control every minute of the day at school. Count on every single day having a surprise for your carefully planned day. Roll with the punches, and pick your battles very carefully before you choose to go screaming through the halls.

When your students come into your room, stand at the door and wear a comfortable smile. They may only glance at you because they are looking to see who the other students are. Nonetheless, they will briefly look *at* you. Quietly welcome them to the room. If you have made student seating index cards, ask the students to find their assigned seats. If you have not made cards, ask students to stand until you can seat them alphabetically. Many changes happen the first week of school. You may not be able to "ink in" your seating chart for two more weeks.

When I call roll for the very first time, I make careful pronunciation marks in my roll card when I ask each student to *tell* me how they pronounce their first and last name. Once I am finished, I will call the *whole roll again* with high hopes that I will pronounce all the names correctly. This always creates many smiles when I get the hard ones right. (Of course, we do remember why this is important to me, don't we?)

Tip 4: Arrange Students Alphabetically

Arrange students alphabetically on the very first day. If students sit with their old friends, they tend to stay with their old ideas.

Art class is an unusual mix of grade levels and academic abilities. I have found that given the opportunity, children will sit with their friends and that usually leads to excessive talking. If you place them alphabetically the very first day, you will not have to deal with cliques. I will discuss with the students my reasons for doing this. I explain that, if they look around, they will see a group of individuals that is unlike the makeup of most of their academic classes. This makes it very special because they will get a chance to get to know a completely new group of people with different experiences in life. Some of the projects will be easy to do and others will seem difficult, and what is hard for one person to understand may be easy for someone else.

"Now," I explain, "take a minute to meet the person sitting to your left and to your right. Remember, these are people you want help from sometimes and you certainly don't want to make fun of their art, because sometimes your own work is going to look pretty weird too!" I usually get a laugh at this. They begin to meet the other students in their own way for a couple of minutes. Very quickly students learn to bond with their neighbors and begin to feel comfortable sharing and asking for help from each other. Watching and hearing another perspective enriches their appreciation for art. I will now begin to engage them in a little discussion, "Can anyone remember any art work they have seen

displayed around school by previous art students? Why do you think that one work sticks out in your mind?" The answers may be about technical skill, or about the content of the message the work conveyed. I will ask if anyone else remembers that particular piece or answer. Someone will agree and there we go—students finding students who share an appreciation.

When I ask for another opinion, I get another kind of answer such as, "Yes, I remember seeing a drawing by Johnny Wilson and I didn't know Johnny could stick to anything that long to do something so well!"

"Well, Johnny did some incredible work in here. I also remember that drawing. He entered it in the Spring Art Show and I feel it was an exceptional piece."

Are you catching on to what I am doing? I am trying to get these students to feel excited about this class as well as helping them to feel comfortable. Remember, the National Honor Society student is just as afraid of not catching on to art as is the Special Education student.

As another bonus, using alphabetical seating allows you to control problem students without having to single them out. I remember one principal, on a surprise formal classroom observation, made this statement about my classroom, "Good job, Mrs. Johnt. I see you have not isolated the difficult students to the back of the room. It was the first thing I noticed."

Tip 5: Introduce Yourself and the Projects
Your Students Will Complete

On the first day with your students, introduce yourself in a way that will connect your life with theirs. Show examples of some of the projects the students will be doing during the course.

After seating and roll call, I introduce myself. I also tell them how to pronounce my name. I tell them where I was born and raised and where I went to high school. I mention my husband and my child and a little bit about each one of them. I list where I went to college and where I got my Advanced Degrees. I mention my past teaching jobs in other cities. I explain why I chose to teach at their school. I like to discuss why I love teaching where I am now. This will be another "hook" because I am letting them know I want to be with them. You will have your own reasons for being happy with your job.

In our first class meeting, I discuss *why* I teach art. This is going to take some soul searching on your part before you can share your reasons with the class. It is a personal reason for each teacher. *I* teach art because I did not have art offered in junior high *or* senior high school. Only boys could take Industrial Arts classes. The boys got to make cool lamps, footstools, and boxes. I distinctly remember sitting at my typewriter in Typing Class and centering a column of words. I remember thinking, "this is as close as I can get to doing something artistic with an assignment." This struck me as tragic and pathetic. I was an average student back then and I had no place to set myself apart from the others. I vowed to myself in college, when I was an art education major,

that once I had the chance to teach art, I would make it a valuable experience for the students.

I recommend that you not spend more than 10 minutes discussing your background, but I certainly would not eliminate *your* story. Your students will be interested in you.

Now is a great time to show some examples of some of the projects the students will do this term. Get them excited! Show some drawing, painting, and sculpting projects you will be teaching. Be sure to show how the students may interpret an assignment differently. Show assignments that will be expressionistic and some that will be realistic. Pull out some of the materials the students will get to use. Show how a work looks different once it is mounted or matted. Do not hold back your enthusiasm for teaching all of this.

Your students will be leaning forward and looking carefully at your examples. They will be grinning at the work and grinning at you, even if they are a little bit scared. Life is good.

Thought Provoking Questions **about Your Art Experiences**

Think back when you were in grammar school, junior high school, and high school. Did you get to take art classes? How do you think art experiences affected your self-esteem and your self-expression? Did you reach your potential with those teachers? How do you imagine your life would be, if you did not have art classes as a child? How do you wish your art classes could have been when you were younger? Why did you choose art education as a college major? Years from now, what do you want your students to remember about you?

Give yourself generous time to think about your answers to these questions, and then answer them in the space below:

Tip 6: Discuss Goals, Finances, and Grades with Your Students

B *riefly, during your first meeting with your students, discuss your goals for the class, financing the class, and your grading system.*

Goals

If you answered the questions on the previous page, you will have an idea about what your personal goals are for your classes. Here are my own goals that I share with every class:

1. Every student will improve in his or her artistic techniques.
2. Every student will improve in their ability to express ideas and feelings through art.
3. Every student will expand his or her appreciation for all forms of art.

This looks basic, yet I want the students to hear my goals for them. What are your goals? Your students do not have a clue about what you expect from them, unless you clearly express it to them.

Finances

Discuss financing the art program right away with the class. We had a countywide student art fee that each student had to pay before one received credit for the class. How could the system do this you may ask? The student could have *chosen* other electives that do not have supply fees. I am very careful how I spend their money. I explain to them that I buy the finest materials that we

can afford. I will buy them wonderful paintbrushes that will not resemble the plastic toothbrush kind that came with their elementary watercolor sets. Has anyone ever tried to paint lips on a painting using a toothbrush? For specific purposes, I will buy them delicate specialized drawing pencils and erasers. I carefully spend their art fees on materials that students do not have access to at home.

Grades

If you teach high school, you know that the first thing on a teenager's mind is, "Can I pass this class?" Get this question out of the way quickly. Every student in my class can make an A if they follow the following guidelines:

1. Come to school every day and do not get behind on your projects.
2. Listen carefully to the teacher's classroom instructions and follow them.
3. Listen to the teacher's individual instructions and follow them.
4. Meet assignment deadlines.
5. Assignments will be carefully prepared and show good craftsmanship.

All assignments demonstrate obvious thought and planning. With these guidelines, it is possible for less talented students to make A's and very talented students to make F's. The student's innate talent is not what one's art grade will be based on. What you do with what you have is how grades will be determined.

Refer to your school's teacher handbook and carefully read about grading. Will you give number or letter grades on tests? How many grades do you need to issue to each student per report card period? Is an exam required each grading term? How often do report cards go out? What is the lowest passing grade? Will progress reports be issued mid-term? Follow accurately your schools grading requirements. Only now can you add your own requirements for how you want to give art grades. Make your own list for what will affect your grading scale:

TIPS FOR BEGINNING ART CLASSES

Tip 7: Assign Three Pre-Instruction Drawings

*A*ssign three pre-instruction drawings for the students to do and file these for review at the end of the course. Explain to the students the requirements for signing their artwork.

Dr. Betty Edwards, in her books on drawing and creativity, has fabulous ideas about the importance of pre-instruction drawings. I highly recommend her books for inspiration. I had an opportunity to hear her speak at an art educator's conference, and I was in agreement with so much of what she had to say about art education. I even suggest students add her book titles onto their "wish lists" for holiday gift giving. These next few assignments were inspired by some Edwards suggests.

Pre-Instruction Drawings

On your first day of class, if you still have time, hand out three regular sheets of plain copy paper to each student. On the first sheet, ask each student to draw a hand. Ask them to include fingernails and skin wrinkles. Announce that 10 minutes will be given to complete the drawing and you will not offer any help or any critique about their drawing. Explain that they are to do their very best because we will compare this drawing with another hand drawing they will do at the end of the course.

Tell them that if they purposely draw poorly, just so their final drawing at the end of the course will look awesome, they are cheating themselves out of a genuine marker of improvement. I might say something like, "This drawing is not for a grade. I keep this drawing and the other pre-instruction drawings in my files. I

return them at the end of the term for comparison to their post-instruction drawings. At that time, each student is able able to judge his or her own improvement in life drawing. These drawings are also fun to take home and show family and friends."

I hope that by now you have a box of pencils and erasers at each desk for the students to use. Let them choose whatever pencil and eraser they want to work with. Walk around the room and look at their drawings. The students will need to get used to you being behind their shoulders. Offer no praise or suggestions for making the hand drawing better but smile and give an encouraging word. This is most difficult for me *not* to instruct. If you have a way to play soft classical or easy listening instrumental music, do so while the students are drawing this assignment (see Tip 91).

On the second sheet of paper, ask for a drawing of a large face, including all facial features, hair, neck, and shoulders. Allow 10 to 15 minutes for this drawing. This time, on the lower left corner, identify the drawing as "Pre-instruction drawing of an imaginary face."

On the third and final sheet of paper, ask the students to draw an imaginary person sitting in a four-legged chair. Do not hide hands in pockets in the drawing. Draw Head to Toe features. Allow 15 minutes for completion. Resist collecting the drawings that are incomplete and make each student finish it. A common tactic for the student is to turn in incomplete work if he is afraid his work will look bad. Identify the drawing in the left corner with "Pre-instruction drawing of an imaginary person sitting in a chair." They may do these drawings during your discussions about classroom procedures. You will enjoy the opportunity to take a deep breath and review your notes before beginning again.

These drawings will stun you. Some drawings will be very crude and some drawings will be excellent. Do not be startled

if some students cannot get the figure to sit on the chair. It is important to try to hide your perplexed expression when you see faces that look like a third grader drew it. Other drawings done will appear so carefully modeled that you know this student spends much time drawing, especially from comic books. If a student giggles and says, "There is no way I can draw," explain that his parents probably draw in that exact child like way.

Dr. Viktor Lowenfeld in his landmark book, *Creative and Mental Growth*, and Dr. Betty Edwards in her fascinating top seller, *Drawing on the Right Side of the Brain*, documented the progression in drawing skills. Without training, most humans develop drawing skills up to about age 12. After age 12, improvements are not made without guidance or training. Not only is that interesting to think about, but once a child has developed his fine motor skills in his fingers, he can draw as well as any adult, assuming he has adequate instruction.

Signing and Collecting Work

Insist the students be consistent in signing their work (see Tip 38). At the bottom left-hand side of the drawing, students should write, "Pre-instruction drawing of a hand." In the lower right-hand corner of the paper, they write their information. It should look like this:

Pre-Instruction Drawing of a Hand Student name

Course name

Class period

Date

Assign the first and the second students on your roll to collect all the drawings. Have these two students wipe off the tables with a moist sponge. They will also make sure the students have pushed all of the chairs in after the bell rings. These two students will be your first class monitors. Allow five to ten minutes for collection and cleaning before the bell rings.

Congratulations! You have just finished your first class. I hope no one tried to pull a chair out from under you.

Tip 8: Establish Student Storage Areas
and Warm-Up Activities

O*n the second day with Beginning Art students explain
classroom rules and consequences (see Tips 16 and 17) discuss
monitor duties (see Tip 18) and issue shelves (see Tip 19).*

Take your time. These three topics, as well as generating
excitement for creating art, are the most important concepts that
one must attend to during the first week of school. Introduce
the students to two more pre-instruction drawings as warm-up
activities afterwards, if time allows. The length of class time varies
greatly from school to school. Your classes could realistically last
anywhere between thirty minutes up to an hour and a half each
day. Therefore, the number of days it will take to cover the above
information will vary as well.

Shelves

Discuss where students are to store their work-in-progress pieces
for the year. Each student should have his or her own individual
storage place. This is extremely important. Each student needs a
specific place to store his work on a daily basis, instead of running
around looking for a harbor for his art.

Sculpture and other three-dimensional work should be stored
in another location. Carefully plan at the beginning of the year
where you will place sculptures-in-progress so others will not
knock them over or damage them. Do not use this area to store
heavy paints or paper. It needs to be free of supplies so it is easily
accessible to the students to place and retrieve their sculptures.

Warm-Up Activities

As an art activity, have students draw an *imaginary* person standing up. Allow about 15 minutes for this. When it is finished, ask students to turn it face down and wait for new instructions.

Now, we add something different to our pre-instruction drawings. Ask a volunteer to stand in the middle of the room and be a standing model. The model will need a short break about every 10 minutes. Have your new class monitors hand out fresh sheets of paper. This drawing is to be of the *actual* model they are looking at. Allow up to 30 minutes for this drawing. Remember, pencils and erasers should already be on each table or desk. Do not offer any assistance on this drawing. Walk around and see how they are doing. Have students identify this drawing, in the lower left corner of their paper, as "Pre-instruction drawing of a live model".

When all have finished this drawing, ask students to turn over the *imaginary* person drawing and compare it to the *live model* drawing. The improvement will be just stunning! Ask what they have just learned. Hopefully, they will realize that direct observation is the key to improving their drawing abilities. I like to point out that I have not begun teaching and here they are already getting better on their own! I will ask the class if anyone would volunteer both of their drawings for me to hold up and discuss the specific improvements. You can count on someone excited to share his or her work. I will hold up both drawings, walk around the room, and ask students to point out the areas that look better on the second drawing. Watch their eyes light up.

When the class is over, ask your monitors to collect all the drawings and give them to you for filing. Have monitors clean off the tables with a moist sponge. Have the monitors check all table boxes to make sure they contain all of the pencils and erasers.

Thought Provoking Questions about Traffic and Storage in the Classroom

Where are students going to store their drawings, paintings, and sculptures in progress? Look around your art room and search for an area you can keep open for sculpture storage. If you have tables set up in a big square, you can set aside an area within the square to store sculptures in progress.

Make sure there are no traffic bottlenecks when students are trying to put their work away. Make sure the traffic flow to the storage areas is free and clear. Draw yourself a diagram in the below space showing how students will reach their own storage area. You may think this is silly, but just wait until everyone is trying to clean up at the last minute, day after day. You will be glad you took the time to make this plan.

Tip 9: Use Still-Life Drawings to Introduce Perspective

O*n the third day with Beginning Art students, assign two still-life drawing assignments.*

I call roll (changes happen). I begin collecting art fees, if necessary. monitors will hand out paper. On the board, I write a list of objects that I want each student to draw. Draw these objects *as if* they all were sitting on an imaginary card table:

1. Bowling pin
2. Box
3. Standing U. S. desk flag
4. Volleyball
5. One-foot tall cone
6. Small pyramid
7. Glass Coca-Cola bottle
8. Oatmeal box (cylinder)

Allow about 15 minutes for students to draw these objects. Be prepared for what you will get. I have seen tables that look more like football goal posts. Identify it as, "Still-life drawing of objects from a verbal description." (You will want to write this title on the board.)

Now, bring out the "real things". I obtained these items prior to the term. I spray-painted all of these objects white with the exception of the standing flag. I give the students about 30 minutes to draw the actual objects. My instruction is, "Look very carefully at what you are drawing." When the drawings are

complete, compare the first and second still-life drawings. Once again, the improvement should be obvious. As the students are drawing this second drawing, you should be walking around and getting familiar with your new students. You will notice students who have no understanding of perspective such as the four legs of the table. You will observe students who do not understand the tabletop foreshortening. You will observe students who cannot place one object behind another. Some students cannot judge the size differences between objects.

This would be a good time to hold up a few examples of this assignment by students in this class, with their permission, of course. Discuss with the class the successful drawings of the above-mentioned items. Point out *specifically* why the drawing successfully captured the look, such as saying, "Karen drew the back legs of the table shorter than the front legs of the table. We know the back legs are not really shorter, but from where Karen sits, the back legs *appear* shorter. Therefore, she drew them shorter and we all believe the table appears to be deeper than if she made all the legs the same length."

Collect and file these drawings away with their earlier drawings.

Thought Provoking Questions **about Your Still-Life Objects**

What objects can you collect and spray paint white? Carefully consider objects for their shapes and sizes. I search for shapes that are round, square, pyramid, cylindrical, and conical. Have some fun collecting unusual objects. By spray-painting the objects, you simplify the shadows and lights that will fall across the objects. Some students will want to add all the lighting details into their drawing. Others will be struggling to get the shapes right. I keep these objects in a big box so I can use them year after year. This collection of objects is infinitely helpful in your observations of the level of skill your students have. You cannot plan a program of Art 1 if you do not have a realistic understanding of the levels of ability your students have. List your ideas below for what you want to collect, paint, and use.

Tip 10: Use Portraits to Introduce Light and Shadow

O n the fourth day with Beginning Art students, have them draw a self-portrait and a partner portrait.

As soon as you can, invest in self-standing mirrors, which are sold through many art catalogues. If they are too expensive, you can have a glass shop cut a classroom set of mirrors for you and then you can strip the edges with electrical tape. Stand these in front of sturdy textbooks. You will need at least an 8x10 inch mirror for a good image. Have monitors hand out the 8.5x11 inch copy paper you have been using and one mirror per student. Ask students to find the light source that is lighting their face other than from above. Is a window also throwing light across their face? Tell the students that they have 30 minutes to draw themselves from the shoulders up. Students will love doing this drawing. You may decide to soften the lighting by turning down the overhead lighting and rely more on window lighting. Identify the drawing in the lower left corner of the paper as, "Pre-instruction drawing of myself in a mirror".

After 30 minutes, hand each student their *imaginary portrait* they did earlier in the week and let them discuss why this new drawing is better. If you feel the group is comfortable with it, let them stand up, turn to the right, and walk around and look at each person's two drawings. I do this quite often. Students will learn to appreciate what they can learn from other student's successes and struggles.

I am certain you will be able to point out how much more expressive and mature these faces look as compared to the cartoon-

like first portraits. I am certain the pencil lines will already have a more interesting pressure and weight to them. You may want to point out someone who has used better composition and space on this self-portrait. Collect both drawings per student. Explain that you will return them at the end of the course, after you teach them portrait drawing. They will enjoy a wonderful set of three drawings to compare their personal growth. It is common for my graduating seniors to keep their original drawings from Art 1 class. It is a satisfying experience for them to recall.

General Tips for Day Four

You may have gotten behind in your explanations of class procedures, discipline, consequences and teaching philosophies. Now would be a good time to see if you missed covering and explaining these issues.

If all is in order, you may let the students use a drawing board (if you have them yet) to draw their table partner. This can be another fun way to get to know their partners.

You will probably still be getting new students or losing students. Keep the seating alphabetical and remember, continue to write everything in pencil.

Tip 11: Establish a Pleasant Routine

I *f you carefully carry out your plans for the first days with your Beginning Art students, you will establish a pleasant routine for the entire course.*

Let us review what you have laid out for the students to believe. Here is my list of what I *hope* most of my students will be thinking:

1. The art room is a nice place to be.
2. I am comfortable here.
3. There is a lot to see and I do not think I will be bored in this class.
4. I do not think there will be chaos in here.
5. I bet I will have to behave.
6. I think my art teacher likes her job and likes us too.
7. She cares about pronouncing my name correctly.
8. I cannot wait to use all these fine art supplies.
9. I will be making new friends in here.
10. Maybe I can start fresh again and build myself a better reputation.
11. I am relieved that I do not have to sit with my friends. I might have goofed off.
12. I am surprised that I am drawing better. This teacher has not even helped me yet.
13. She clearly explains what she wants from us.
14. I was afraid I would not know what to do in art, but now I believe I will be able to learn.

15. My teacher is relaxed and that helps me feel relaxed.
16. My teacher does not make fun of me or of anyone else, yet she seems to have a good sense of humor.
17. I am looking forward to coming back here tomorrow.
18. If I do my best, I can get a good grade.

WOW! This is some kind of ambitious wish list for student responses! But I have actually heard every one of these responses at different times. Students rarely try to get out of my class. I have often heard that I am "lucky" to have such great kids sign up for my classes. This may be true because good students tell other good students what a great class this will be. However, I don't think that's the whole story. I believe we *train* our students to be well behaved, eager, brave, and adventurous learners during the first week of school.

TIPS FOR ADVANCED ART CLASSROOMS

Tip 12: Remind Returning Students
of Policies and Procedures

O n your first day with Advanced Art students, review your classroom procedures such as seating assignments, art fees, room monitors, and classroom rules and consequences. Discuss your sketchbook requirements and some of the exciting projects they will do.

Oh, how wonderful it is that these fresh, talented Advanced Art students know how to behave from having had Beginning Art! Some of these students have had you before and they know you are consistent. They know you know your craft and that you will help them to do their very best work. They know you will give plenty of individual help, yet you will let them explore their unique and original ideas. They know, in advance, the work they do will create interest and awe from the student body and the faculty. How do they know this? Because they have seen past works by Advanced Art students displayed around school and they have heard about art shows those students participated in. While your Beginning Art students probably know of past art students who are in college and are majoring in artistic fields, your Advanced Art students know, or have heard, of past art students who are making a living at what they love to do.

To get the year started on the right foot, you simply need to remind your returning students of how your classroom runs best.

1. Call roll and place the students in alphabetical order.
2. Assign your first two room monitors and review the rules for this duty.

3. Review the classroom rules. Ask once more, why these rules are important.

4. Review the consequences for breaking the rules. Do they remember from their Beginning Art class that you actually do assign punish work? This reminds your students that you do follow through with your discipline plan.

5. Discuss how the art fees are collected. If you are to collect it, you may begin today. Make sure you give receipts. You cannot be sloppy with collecting money and documenting it properly to the office.

6. Discuss your requirement for a sketchbook each student will do and how you will grade it. I will discuss this in detail elsewhere in this book.

Now, here is the fun part. Get them excited about some of the projects they will be doing this term! Tempt them with examples of assignments they will be doing. Point out how these projects will be different from what they did in Beginning Art. Show them some of the supplies they will be using. Explain how you will show some of these assignments in art shows or will be included in their college portfolios. Ah, yes, now they are chomping at the bit to get started!

Tip 13: Establish Student Storage Areas and Advanced Warm-Up Activities

O*n the second day with Advanced Art students, assign shelves for storage, art boxes, and portfolios. Assign one live figure drawing as a pre-instruction assignment.*

Shelves, Boxes, and Portfolios

Issuing individual art shelves to your Advanced Art students is exciting to them. I assign them two shelves if possible, one for their portfolio and one for their work in progress. This is a little thing to make them feel special. I discuss storage tower ideas in detail in Tip 19.

Issue Advanced Art students their own art box to use throughout the course. It includes a wide variety of drawing materials that will be helpful when working in their sketchbooks. Students will return this kit at the end of the course, before grades are issued. The art box is their personal badge that says, "I am an Advanced Art student." Your art students walk around campus with their art box as they do with their books. Students are always excited to get their art box at the beginning of the term. I will discuss these boxes in another chapter.

Issue Advanced Art students a good quality portfolio. You might require that they make their own or buy one, but I prefer to issue them and collect them at the end of the course. Strong handles, Velcro flap closures and plastic coatings are very helpful. This protects their assignments during bad weather as they run to their cars or to the busses.

Advanced Warm-Up Activity

Ask monitors to hand out 8.5 x 14 inch drawing paper. Ask if someone will volunteer to be the standing model. The model will need to stand in the middle of the room. The drawing of the model will take 30 minutes. The students may choose any pencils and work in any drawing style. Put small bits of masking tape on the floor as marks for the model. The model needs to take a short break about every 10 minutes.

Advise your model not to brace his or her knees. As is taught in band, chorus and ROTC, if a student braces their knees, blood flow will decrease to the brain and the person may faint. This actually happened in one of my classes and I will never forget it! The boy fell, hit his head, and blood flowed. I put on a plastic glove, ran to compress the wound, and sent a reliable student to get the principal. I told the students to remain calm and stay in their desks, but they were scared. We all remained calm, the student regained consciousness quickly. The principal called the student's parents and they took him to the hospital. The principal and I filed an accident report. As we discovered, the student had been fainting before; the parents now took this opportunity to find out the cause. The student and I bonded by this ordeal. He came by to see me throughout high school. I can laugh now when I tell the story, but it was not funny at the time! Again, assign breaks every 10 minutes and remind models to keep their knees relaxed.

Tell your Advanced Art students that this live figure will be a pre-instruction drawing. You will not be giving tips on how to make the drawing better. Offer drafting tape to hold their paper level on their drawing boards. Walk around the room occasionally to see their progress. Smile and offer encouragement but do not help. Play soft jazz or classical music if you wish (see Tip 91).

This drawing will help students recall what they learned in Beginning Art. The time allowed for the drawing will help students remember to stay focused on the model and their art. During this drawing time, you will have a chance to see how many of your students remember body proportion, shading techniques, line qualities, expressive qualities, composition, and value.

Have the students sign their drawings as shown below (also, see Tip 38). Collect and put these drawings away for comparison with post-instruction life drawings done at the end of the course. I hope that just like your Beginning Art students, the Advanced Art students will be able to see their drawing skills improve during the class.

Pre-Instruction Drawing of a Live Figure Student name

Course name

Class period

Date

Thought Provoking Questions about Your Introductions to Advanced Art Students

Let us assume this is your very first year of teaching art. Let us assume that your Advanced Art students had someone who taught art differently than you would have in Beginning Art. Let us assume that, maybe, just three days ago you were hired!

When you explain the types of projects you have planned for the students, what can you use for examples? Will you need to explain classroom procedures exactly as you did for Beginning Art? Will you need to introduce yourself and discuss your motivation for teaching art? How can you project what you envision for them as a group? What opportunities will you give to them that you will *not* offer to your Beginning Art students? What were your own experiences with your upper level art classes in high school, and how do you anticipate that experience will affect your teaching style? Consider these questions and answer them below:

Tip 14: Use Still Life Drawing to Remind Students of Techniques

O n the third day with your Advanced Art students, allow a whole class period to draw a pre-instruction still life.

If you like, you may use the exact still life you constructed for your Beginning Art students. Alternatively, you may want to cover a table with a white tablecloth, add extra and more complex white spray-painted objects, staggered by heights and depths. If the class is more advanced, you may want objects with complex textures, fuzzy edges, strong values or color. I collect objects with rounded and flat edges. I create folds of cloth and curving lines. No matter what your still life, put a spotlight on it, so the shadows become more obvious. If you do not have a spotlight, lower the room lights and let window light flood the objects.

You will need drawing paper and drawing boards, if available. Students use drafting tape to hold drawings in place on their boards. Use your monitors to assist you in any way needed. Students will choose drawing materials from their art box.

Do not forget to take roll and collect fees. Ask if anyone is expecting a schedule change. Ask if anyone is here for the first time. You can expect more changes in your roll throughout the next two weeks. Always ask a new student to show you his official new schedule. It is not unheard of for a student to try to get into your class on the sly. Send any student not assigned to your class to the class listed on his schedule. That teacher can write a pass for the student to go to the powers in control of scheduling. Otherwise, send him to the office.

Once your students begin their drawing, they may remember to use their pencil for sighting angles. They may remember to softly squint their eyes to see value changes. They may remember how bounced lights on objects affect shading. They may add in background values to make highlights on objects sparkle. They may remember to let objects run off the edges of paper for visual interest. The important point is to let the student make these discoveries again. This highly complex drawing done without any of your assistance will encourage the students to jump right into their sketchbooks. Without your assistance, the students will remember the power of quiet and intense observation. Keep the soft music playing during this time (see Tip 91).

Leave some time at the end of class for you to catch up on the students' personal activities from the last time you taught them. For instance, you may ask, "How is your band doing?" or "Did you get to take that trip to New York this summer?" However, for heaven's sake, if you *ask* a question *listen* to the answer. Remind the monitors that when it is five minutes before the end of class they are to straighten the room and clean the tables. *Do not forget. These monitors must report to you when they finish, before you award them a daily monitor grade. Write their grades immediately in your grade book, before you wave a fond dismissal to your helpers.* I discuss monitor duties in more detail later in this book.

Tip 15: Use Portraits to Engage Students in Class

*O*n *the fourth day with your Advanced Art students, hand out mirrors and have the students draw self-portraits for their final pre-instruction drawing.*

Usually, your Advanced Art students already know how to stay involved for a long time with a drawing, which will add to your enjoyment as you watch these drawings develop. Have monitors hand out paper and allow time for students to sharpen pencils. Students need time to tape down their papers and to get comfortable with their poses and lighting.

Continue walking around to watch their progress. As you come by, your students may have topics they would like to share with you. Linger, listen, and talk quietly to each student. You are trying to set up a rapport with each student, which you hope will continue for the course. It is far better to start with a non-adversarial relationship than to repair a damaged relationship later. I do not agree with the "Don't smile until December" style of teaching.

Your students may even enjoy that you are not trying to teach them yet. Let them study and discover their own faces. Lower the lights if you like and let natural light shine in. Play your soft music (see Tip 91). There will be a little talking among the class, but that is all right. You want there to be camaraderie among the students. If comments begin to interfere with the classes' ability to concentrate, you will have to insist that all talking stop. If students make comments that make others feel uncomfortable, you will have to stop that talk. I enjoy a little spontaneous talk

that relates to the assignment. We can all laugh or sigh together. Remember, we are trying to create a comfortable, yet productive environment.

Explain to the class that there will be a portrait-drawing unit taught later. They will look forward to your assistance. Comparing today's drawing with the later drawing will be a lot of fun. After completing the Post-instruction drawing, we put the two drawings side by side on the tables and walk around to see each person's progress. It is always fun to see the improvements at the end of the term.

Ask the monitors to collect the drawings. You will choose a place to store them. Allow the students to put away or take home their art boxes. Monitors need to clean the tables and go through their checklist of duties. When the monitors report to you for inspection of the room, record their daily grade and dismiss them. This should have been a very pleasant day.

There is a good chance that the first week's planned activities for the Advanced Art students has taken more than four days to complete. You will find your own speed.

You have established for these students the same atmosphere you established for your Beginning Art students: enthusiasm for learning art, confidence in their own ability, comfort in the environment, and trust and respect for you their teacher. You have just accomplished some of the most important work of your year.

Thought Provoking Questions **about Evaluating Your First Week**

At the end of your first week with your Advanced Art students, take a moment to evaluate the student/teacher relationships that are developing. Answer the following questions honestly (no one has to see these answers but you):

1. Are the students developing a "them against me" attitude?
2. Are the students condescending in their responses to me?
3. Are the students making fun of me?
4. Are the students refusing to follow my instructions?
5. Are the students grumpy and irritable in class?
6. Are the students treating the class as a party room?
7. Are the students trying to get out of your class in droves?

If you answered "yes" to any of the above questions, you have a real problem and you must deal with it immediately!

You must not ignore a poor first week relationship with your students. Review how you approached the first week. What could you have explained better? Have you shared ideas about some of the exciting and complex projects they will be doing? Are you following through with all that you said you would do? Are you coming across as a bully? Are you fully organized? Do you appear relaxed and glad to be there? Do you allow yourself and your students some humor? Below write a plan of action on how to correct your problems.

Tips for General Classroom Policies

Tip 16: Create a Discipline Plan for your Classroom

M*ake an exhaustive list of what would make you "lose your cool". Review your list and highlight the top five. This is the basis for your discipline plan; one you will eventually post for all to see.*

Teacher wisdom holds that one should not have more than five classroom rules. Having more rules will only frustrate the students and keep you, the teacher, constantly looking at a longer list. Mr. Dana Magee, my first junior high school supervising principal in Slidell, Louisiana, taught me to make this list. It was so helpful; I used it in high school, too.

Over the years, I have come to settle on five rules. On the following page, you will brainstorm your own. Here are my classroom rules:

1. Be prepared for class
2. Be courteous to the teacher and your classmates
3. Protect the safety of yourself and others
4. Follow the teacher's directions promptly
5. Follow the rules in your school's student handbook

Post your rules in the front of the classroom on a large mat board or laminated poster. Be sure they are visible to all students. Make a well designed and neat poster that students will enjoy seeing.

Hang this list of rules *before the students ever enter the art room!* You need to be clear from the very beginning what is important to you. When I introduce the rules in the first week of school, I carefully give examples of what an infraction would entail.

For example, if I'm addressing my first rule, I might say something like, "If I have requested that you bring three leaves to class, I expect you to have them when you enter class. The leaves are the homework assignment. Without them, I will have to take valuable teaching time away from the others just to get you started. *Be prepared for class.*"

For the second rule, I would offer, "If a student comes to class wearing old shoes and another student says, 'those shoes wouldn't sell at the Goodwill Store in the bargain box', or 'if my art work looked like yours I would try to get into Chorus class', or 'Hey teacher, this is who I am, you can just get over it.' *These are all examples of being discourteous.*"

For the third rule, I might add, "Let's say you take your detailing knife and start stabbing your neighbor playfully, or you start a jousting tournament with the nice aluminum yard stick. (Pick up a yardstick and demonstrate this funny scene.) *These are considered examples of not protecting the safety of others.*"

I usually cover my fourth rule like this: "If I ask you to 'sit down', that means *sit down now*. The word *promptly* means do the request now. I do not intend to waste our art time repeating myself. If all I do is repeat myself throughout class, you lose your desire to listen to my instructions and you will not be able to create highly thought out art works. Our time in art is precious and we are all fortunate to have this uninterrupted time to explore our individual and unique talents. *Follow the teacher's directions promptly.*"

Finally, I talk about my fifth rule by saying, "You have all been given a student handbook covering the school's rules, the county's rules, and the state's rules. I suggest you pay careful attention to the sections on fighting, stealing, vandalism, profanity, and truancy. I will follow the handbook's requirements on how I respond to

infractions. I will not ignore or look away from students who break these rules. Now, you may be thinking I am rather humorless and how will this class be fun. I *promise you,* you will be too busy with your exciting projects to get into trouble, you will not want to do inferior work, I will help you everyday to do your best work, I will carefully plan art projects that are fun and challenging, and the projects are not beyond your capabilities. You do your part, and I promise to do mine with humor and joy. I cannot wait to get started! *Follow the rules in the student handbook.*"

By giving examples of each of the five rules, each student will take a moment to digest what each rule means. It is much better to discuss this in detail at the beginning of the course than to spend the whole term trying to decide what your boundaries are.

Thought Provoking Questions **for Creating Classroom Rules**

Be very honest with yourself. Try to imagine situations where you would get frustrated and feel out of control.

What situations would make you want to yell? What situations would make you act nervous and fidgety because you do not know how to handle the situation? What situations would make you act ridged and unapproachable? What situations would make you cry? What situations would lead the class to make fun of you to your face?

Your answers listed below will help you select and devise your five classroom rules.

Tip 17: Post Consequences and Design
Punish Work Assignments and Forms

K *eep at least five separate punish-work assignments at your desk;
having these at your fingertips will give you immeasurable
confidence in your ability to manage the consequences of a student
breaking your classroom rules.*

Consequences

The following are the consequences for breaking my classroom
rules:

Consequences for Breaking Rules

1. The student will receive a verbal warning.
2. The student will write a one-page summary on a given
 assignment.
3. If the student does not turn in the one-page paper by the
 next class period, the assignment doubles for the next
 period.
4. If the student does not turn in the two-page assignment
 by the next class period, the principal receives a student
 referral.
5. If a second rule is broken and a one-page summary is
 issued, the teacher will note discipline problems on the
 student's report card and will phone his or her parents.

I post these consequences under my rules and I discuss each
step I will take. I even go through an imaginary scenario. Students

benefit from seeing how you think and how your logic works. This information helps them plan how they choose to behave in your class.

Punish Work

For punish-work, I collect many art articles for students to read based on their reading levels and interests. Each article I choose has interesting visuals and easy to read print, and it should take the students about 30 minutes to read. At the beginning of each article, I write very specific instructions for the students to follow. For example, "Read pages 16, 17, 18, 19, 20, 26, 28, and 30. Write by hand a neat one-page summary of what you have read. At your next art class, return the article in its bag, along with your summary. If you fail to follow the above procedure, you are to write a two page summary due by the next art class."

When I issue punish-work for breaking one of my five rules, I make an immediate note, in red, in my roll book in the next day's attendance column.

Let us say Kim gets punish-work on Tuesday to do a summary on Monet. On Tuesday, I go to Kim's name in the roll and for Wednesday's date, I place a tiny *Monet* in red, this way, when I call roll Wednesday I will not forget about her assignment. The great thing about this plan is once the student has "paid the price" for her misbehavior, I can really forgive and forget. Here is why: If *I* stay in at recess with the child, *we both will be punished. I* need a break from the students so *I* can come back renewed. Also, make a mental note, here: *NEVER conveniently "forget" to collect a punish work assignment because you are not mad by the next day. All the students will notice is that you do not mean what you say.*

Now, let us go back to Kim and her Monet summary. Assume for a moment that Kim comes in on Wednesday without her

report. Kim gives you a sad story about how she had to work at her job, and so on. After I give her a moment to explain, I simply remind her that I am sorry she had to work last night, but she will have to turn in a two-page hand written summary tomorrow. There will be no arguing. I already discussed the rules and the consequences for breaking the rules at the first of the term.

At this point, I will write the number *2* in front of the word *Monet* in Kim's attendance space for Thursday. This is my prompt to remember to ask for two pages from Kim at that time. I will not scream across the room for her to bring me her report. I will call her to my desk and look her in the eye as I ask quietly for her work. There is no reason for me to be nervous because I know exactly what I will do next if Kim does not have her two-page report.

Principal Referral
If a student fails to hand in the two-page report, I write a disciplinary report to the appropriate principal. I write a standard statement like this:

My student, _____
was issued a written punish-work assignment for_____
_____ (whatever
the broken rule was). The student had two opportunities
to do this work but chose not to do it. Please assign an
appropriate punishment for this infraction based on the
student's previous discipline record. Thank you for your
support in this matter.

Still using Kim as our example, let us see what the principal might do. If Kim has never been in trouble before, he may issue her some kind of school detention. If another teacher sent Kim

to the office one class period before for profanity, the punishment might be stronger, such as Saturday school. If this was Kim's first day back after a drug bust at school, a principal may suspend Kim for breaking my rules.

It is difficult for us as new teachers to see the big picture. We have to have faith that the office knows more about the student's disciplinary history than we do. I do know this; I always got support when I sent a request for discipline to the principals. Why? 1. I carry out discipline in my room in a consistent manner. 2. The students know the rules and they know what will happen if they break a rule. 3. I assign and collect my own punish-work before I refer a student to the office. 4. I do not have "bad days" where I lose all sense of reason, or "good days" where anything goes in my class.

It may take a year or two before the principals develop faith in your judgment. The principals will be willing to work with you and not question every little decision you make. Most telling, the students will know if you send one of them to the office, there is a very good chance the student will not be able to talk their way out of punishment. I rarely sent students to the office when I was teaching, maybe four times or less per semester. Of course, you should immediately call for help from the office if a dangerous situation arises. Do not be so arrogant to think you never need help.

Parental Referral

Parents can be a tremendous support for you if they believe you explained the rules to the students and you do not show favoritism.

Once I assign a student their second (or third) separate punish-work assignment, I contact the parent(s) by phone and

inform them of the required punish-work. I would also make a comment about their child's behavior on the student's next report card. I would very clearly document these communications with the parents in my grade book.

I have observed over the years that parents will diligently seek answers about your fairness as a disciplinarian. If a parent believes you are singling out their child, you can be sure you will face a very unhappy Mama and Papa Bear.

If I had a student that required a fourth punish-work assignment, I would let the principal handle this discipline problem. I would send a note to the principal explaining everything that had transpired.

There comes a time when I have spent enough effort and time on correcting discourteous attitudes and disruptive behaviors. I cannot shortchange the rest of the classes' opportunities to create and love art. The class deserves my best attention to each student's unique ideas and efforts. I feel almost euphoric when a class is in a highly creative mood. It is a joy to be a part of this complex learning environment. Everyone loses track of time. When a student asks himself the right questions about how to express his visual thoughts, I feel thrilled to be there to answer his questions, and to rouse his deeper ideas and visions. If I am all wrapped up in being at war with *one* student, day after day, well, you see what will happen. That *one* student is demanding and *getting* far more attention from me than are all of the hard working students.

Thought Provoking Questions for Finding
Sources for Punish Work Assignments

You may not care for my punish-work assignments. Current thinking is punish-work should have some worthwhile meaning and benefit and I agree. You may feel it is inappropriate to use art history as any type of punishment. I could see your point, although I have not found that to be the case. Often times, my students will find a new interest in the artist they did a report on, especially if the color pictures in the article were of a good quality. I try to match the report to the particular student's interests. At my school, our reading scores were poor, so having a reading assignment aided and supported independent reading. I tried to collect readings on a wide variety of styles and periods. I collected readings on Frederick Remington, Mary Cassette, Cave Paintings, Red Grooms, Michelangelo, Audubon, Jacob Lawrence, Pop artists, Folk artists and many more.

Where did I find these articles? I found them in teacher journals and in art student magazines. I found them in adult drawing and painting technique magazines. I found them in articles published in Time, Life, People, National Geographic, and Reader's Digest. I bought large zip-locked bags to hold each article. I wrote my name on the outside of the bags in permanent marker. I kept them all in a six-inch wide magazine file on my desk. If the class is misbehaving, I quietly walked to my desk, picked up this file, and walked with it in my arm as I continued to speak. I do not have to say a thing about what is going on. They all get the message! Anything we can do to prevent disruptions and arguments furthers our goals of fostering a creative and pleasant atmosphere.

Where could you find sources for punish-work? How can you plan an assignment that will take less than one hour for the student to complete? List below some of your own ideas for what to put in your punishment work zip-lock bags:

Tip 18: Design a Room Monitor System

Assign two students, alphabetically, every week to be room monitors. Hold these students accountable for the condition of the classroom and issue a project grade for their efforts.

The purpose of the room monitors is to ensure that the classroom is neat, clean and orderly for the incoming class.

Explain this monitor system in detail to the students during the first week of the term. There will be two monitors per week chosen alphabetically. Make a nice, laminated poster with the nine monitor duties clearly listed and place it where all students will easily see it. Leave the poster up all year.

Five daily monitor grades will qualify monitor duties as a project grade. A student can make up a missed daily monitor grade if the student misses a day due to absence. When another monitor is absent later in the course, the student will make up for the missed grade. I issue daily monitor grades after both monitors report to me at the end of the class when they have completed their duties.

Here is my monitor checklist:

1. Remind the class when it is ten minutes before the class dismissal bell rings.
2. Check to see that all tables and/or desks are in original order.
3. Clean all tables and desks with a moist sponge. Clean and dry the sponge and leave it at the sink.

4. Look for paper and supplies that may be on the floor or left on the tables. Ask the student who left these materials to clean them up. Monitors will clean up any remaining spills or trash and put away materials that remain.
5. Empty the pencil sharpeners and dust around them.
6. Make sure all chairs are in order when the dismissal bell rings. Remind students to come back and push in their chair if they forgot.
7. Clean the sink and the areas around it. Store paintbrushes properly. Water containers are to be empty and clean.
8. Clean up any art medium spills on the floor.
9. Finally, the monitors report to my desk to receive a daily monitor grade and my permission to leave class.

When I introduce these monitor duties to each new class, I will go over each one. I want the *reason* for these duties to be forefront in their minds throughout the year. I never have to go over them again. I want each student to see how he or she personally will benefit from the system.

I explain that I select the two monitors alphabetically so I will make sure everyone gets his or her turn. If we get to the end of the roll before the course ends, I will ask for volunteers. It has never been a problem. Sometimes I start all over again.

As an added bonus, this system gives students one more reason to get to know their table partners: they will be working as a team as monitors.

Rationale: **Monitor Checklist**

1. Remind the class when it is ten minutes until the bell rings because students will be deeply involved in their projects. That is good! (Have you noticed that the boring classes never seem to end?) Students will need time to put away their work and to make mental notes about where they will start tomorrow. Students may need time to check out supplies to take home. They will need time to put away their supplies for the next class to use. If they are not through putting things away when the bell rings, some will miss part their recess or lunch. If the monitors have to clean up for a student, you can be sure they will be annoyed, because they cannot be late for their next class, and if the classroom isn't clean they cannot get a good daily monitor grade. I should not have to write a late pass for the monitors to go to their next class. If they have to leave before the room is clean, *I* have to clean the room instead of greeting my next class with good cheer. If I spent my day cleaning chairs and tables for 120 art students, there would be nothing left of me but an exhausted shell. Make an atmosphere where students create fabulous work. A comfortable atmosphere is necessary. Classroom monitors help me do this.

2. Tables, desks, easels, whatever you are using, need to be in the same place each day, because the next class may be working with a particular slant of lighting. The art room will have certain pathways for all to get used to and come

to expect. We do not want people tripping over things and bumping table corners all the time. There is a lot more movement in an art class than in most other classes.

3. Table tops need to be clean. I give an actual example here. "Imagine this were your drawing." (I hold up an excellent student graphite drawing.) "Imagine you had worked on it for five class periods and had taken it home to work on. Imagine that this artist plans to put it in the Spring Art Show. Imagine that this young man cannot wait for his grandfather to see it when it is finished because he had recently disappointed his grandfather. Imagine the young man, working on this drawing, comes in next class and sets it down on a spot of red paint. Have any of you ever tried to erase red paint? What would happen? Would the paper shred? How could you cover red paint without creating a shiny spot? The paint cannot be hidden on the paper. It is exactly for this reason that we must leave our tables so clean. Just because your class is painting, does not mean that the next class will be doing what you were."

"I am going to show you how to wipe off a table with a sponge. Surprisingly, some of you do not know how. I will show you why it has to be done with a moist sponge." I go to the sink, get a sponge, fill it up with water and I take it dripping to a table where some poor student is mortified that I might drench him. I will flop down the sponge on his table and flippantly warn the poor child to watch out. As I sling this sloppy mess around, I mention that I have had less water than this to water ski on before. I ask, "How long will it take for the table to dry off. Will it be

dry by tomorrow?" I now get a big wad of paper towels and dry the mess off. This takes a while too. "O.K. then, let's try it another way." I take the sponge to the sink, rinse and squeeze it out. I return to the table, look at the same victim, and ask, "Are you feeling a little better about it this time?" As I clean the table, I say that I have to press down to remove the unseen graphite smears. I mention that the table will be dry in minutes. I may have to rinse the sponge out and return to do all of the tables. I return to the sink, rinse, and squeeze out the sponge for the next class monitors. "Now students, I know it seems silly to show you how important it is to clean the tables, but just remember...what if it were *you* coming in with that fine drawing?" (The students smile and nod their heads, as they would all go crazy if the drawing was ruined.) I rest my case.

4. Pick up paper on the floor and supplies left out of order before the next class arrives. It is too hard to hold someone accountable at the end of the day for the condition of the room. Your monitors should ask the other students to clean around there seats. Monitors seem to enjoy an authoritative playful role they assume. When a student is a monitor, he gets to meet every student in the class as he oversees clean up.

5. Your pencil sharpeners can create a big mess. The graphite residue gets on everyone's fingers and artwork. Air conditioners and heaters spread the dust around, too. Keep your sharpeners emptied and clean around them with a damp paper towel each day. If you draw often at

home, this may seem a bit excessive to clean so often. Remember though, you have over a hundred artist in this room sharpening their colored and graphite pencils every day.

6. Your students need to push in their chairs. Before I insisted on this, my class would leave a jumble of chairs everywhere. When the next class arrived, they searched through the chair options to find their favorite one. It was chaos! Keep an eye on your monitors when they clean tables, be sure they do not push residue *onto* the chairs. I have seen many students who have ruined their pants because of oil pastel flakes on their chairs. Of course, it is annoying to have students who are so preoccupied with their clothes that they do not want to loosen up and create. You will just have to prod them to lighten- up and get involved in their creations. You have to remember that all of your students are not going to major in Fine Arts in college or desire a Bohemian appearance, although that would certainly cut down on clean up time!

7. Have your sink areas clean and dry by the time the dismissal bell rings. Water on the floor is *very dangerous.* I keep a mop and bucket handy at the sink area. Paint supplies left in the sink could get on everything in the next class as they clean up. Paintbrushes need to be stored properly in a convenient area with water protection underneath them. How many times have I had a stack of paper ruined because water from the sink area leached onto the paper? Have your monitors dry around your sinks at the end of class.

8. Any spill onto the floor needs attention immediately. I explain to my classes that accidents will happen and inks spill, and pastels crush under their feet. If an accident happens, I assure the students that I will not scream and embarrass them. I expect the student to clean up immediately the mess created. The monitors should not have to clean up a student's accident. If a student has an accident with supplies and walks away from it without acknowledging the accident, I will issue a verbal warning or punish work, depending on the offense. I know when an accident happens for the first time in the class; all eyes will be on me to see my reaction. I am so careful not to make a big production out of it. I simply go to the accident and offer to help the student find appropriate cleaning materials. I will not embarrass the student about the accident because we all have them. You may have to ask a Monitor to *help* the student with the clean up if it is a big job.

9. The monitors need to report to you at the end of class for their daily grade. You need time to scan the room to see if it is ready for your next class. I will think aloud, "Tables clean? Spills cleaned? Sink cleaned? Supplies returned? Chairs pushed in? Art projects put away? Paper off the floor? Pencil sharpener area clean?" Once you are satisfied with the condition of the room, enter a daily grade in your roll book for each monitor. I take a moment to look into the eyes of my monitors and tell them, "Thank you, I could not teach without your assistance. You did a fine job. That will be an A for today. I'll see you tomorrow!"

Rationale: Monitor Grades

Let me explain how I average monitor grades into my grading system. This has worked for me and it is very easy for the students to understand and follow. During the first week of school, I will draw an imaginary grade book diagram on the board. I explain the grading procedure with each class. Once again, the more you explain your procedures in advance, the less trouble you will have with your classes.

Explain to your students why and how you do the things that you do. They will respect you, and thank you for being unambiguous.

Example of how monitor grades look in the grade book

February	2	3	4	5	6	9	10	11	12	13
	Mon	Tues	Wed	Thurs	Fri	Mon	Tues	Wed	Thurs	Fri
Adams, Kevin	(a)	(a)	(a)	(a)	[A]					
Anderson, Kristy	(a)	(a)	x (a)	(f)	[C] (a)					
Brown, Janna						(a)	x	(a)	(a)	(a)
Butler, Jared						(a)	(b)	(a)	(a)	[A-]

You may be required to keep letter or number grades in your grade book. I make lower case letter grades to represent a daily

79

monitor grade. I draw a circle around them. I capitalize the final weekly monitor grade and put a square around it to let me know that all five days are completed. I count a final grade of A as a numerical 98 and average this grade as a project grade. You can devise your own numbering system.

To understand the system, let us look at Kevin Adams first. Kevin was present all week and did a good job too. He reported to me each day at the end of class to get his daily grade. On Fri., instead of a lower case *a*, I wrote in a capital *A*. This tells me that when I average grades, Kevin will have an extra project grade of a 98 (or higher).

Now, let us look at Kristy. Kristy helped clean on Monday, and Tuesday and reported to me to get her daily grade. On Wednesday, Kristy was absent and another student took her place to clean, another student who was lacking a daily grade. On Thursday, Kristy returned to school but did not help clean up. (Kristy was in a hurry to see if her boyfriend was talking to his old girlfriend at recess, so she bolted when the bell rung.) I gave Kristy an *f* for Thursday. Remember, instead of now greeting my next class at the door, I am cleaning-up a big ink spill at the back of the classroom! On Friday, Kristy does a good job and I pencil in an *a* on that day. Kristy will not receive her final monitor project grade until she makes up for missing Wednesday. Two weeks later, Mary Carter is absent and Kristy will make up her missed day then. I will look back at the grade book and enter an *a* for the day she was absent. When I average the five grades together, I get a C average for Kristy. *No one receives monitor duty credit until five days are complete.* I transfer partial duty grades onto the next grading term if make-up days are not complete in the term.

Can you figure out what is going on with Janna Brown? Yes, she was absent on Tuesday and must make up one day. Next, we

look at Jared Butler's monitor grade. He did not do a great job on Tuesday, but he still got a low A for the week.

We have reviewed (in *detail*) how you might approach your first and second weeks of school. I am sure you never thought so much was involved in planning this crucial time. Oh, I know what you are thinking, "Good gosh, just get going and have some fun! School is tough enough as it is!" Uh-huh, yes. I feel the same way, but remember you are dealing with children and young adults. If *you* do not have procedures, *they* will develop their own. I can assure you, the plans they have for running your class will not be what your supervisor has in mind. Just try backtracking to gain control of the class. Yes, it can be done, *but with great pain and gnashing of teeth!* Oh yes, it is much easier on you to establish routines early on. After the students catch on to the art class routine, you will be delighted at how happy and satisfied everyone is, *including you.*

Chapter 2: Classroom Organization

Tip 19: Build Storage Towers for In-Progress Student Work

*A*rrange *a plan to build two storage towers to hold in-progress works. Number each shelf and assign each student a numbered shelf.*

Design your two storage towers so that the shelves will hold papers the size of a portfolio. Allow a height of about 1 to 2.5 inches between each shelf. The thin shelves should be made of a smooth textured composite board. To the side of each shelf, write a permanent number. Give each tower a name, such as the North Tower. Every student should have his own shelf for the whole course. The shelf is for saving paper and canvas, and even very shallow paint palettes with snap-on lids or other items needed daily. It is a wonderful place to store individually numbered drawing boards too. Write a permanent number on each drawing board to correspond with each shelf number. Check the condition of each drawing board and shelf before you assign it. Students will be less apt to carve into a drawing board if they know I am keeping track of the boards. Each issued shelf is not to store pencils, paint tubes, pastels, or art supplies. These are the items that will get pushed to the back, leak, or be stolen.

I used two towers because I did not want 25 to 30 students all huddled at the same spot trying to get their projects. Split the class evenly, half the students storing work in one tower and the other half of the class storing in the other one. If you place the towers on opposite sides of the room, you will have a much better arrangement. I issued each student a number during the first week of school. I had them come to their tower and find their number.

They will need to write this number in a notebook were they can find it if they forget it. Many times, when a student is out of school for several days, a friend will come to get work for the sick student. All I had to do was look in the grade book to see what the student's shelf number was. Ninth grade Art 1 students are shorter in general than are my Art 3 students. Therefore, I put the ninth grade students' shelves at the bottom of the towers, so they would not have to reach above their heads for their work.

Because each student has his own numbered shelf, it takes a very short time to get his work and start. If each student has a place to keep their work, they will not be frantically searching for assignments. At the end of the course, each student must clean out his shelf. After the students clean their shelves, I would ask several of my bigger students to tilt the towers forward to dump out anything that may be stuck in the back. A cork-backed yardstick works great as a gripper to pull out stuck paper.

Tip 20: Keep a Wish List for Supplies

*K*eep the balance sheet of your available monies handy at your desk. Keep this in a manila file folder along with copies of the order forms for materials ordered this term. Insert in this file a blank, lined sheet of paper and title it "Wish List for Supplies."

It is nice to know how much money you have to spend. When I was teaching, I kept a running balance sheet similar to a checkbook register. I always had a clear record of deposits and expenditures for purchase orders. Keep all purchase order numbers listed next to the supplier who you ordered from, and list important dates relating to the orders. Do you want to make your school secretary angry? Just try going in to discuss an incomplete order you have received and you do not know the purchase order number.

Knowing how much money I had available let me set realistic goals when trying out a new project. If I had a $100.00 balance, I could not entertain the idea of buying supplies for a linoleum block printing assignment that required 11x14-inch blocks, printing paper, inks, and brayers. *Never* overdraw money in your art account. This kind of irresponsible bookkeeping can keep you from being asked to come back to teach for a second year. *Always know how much money you have to spend.*

Along with your balance, keep all yearly purchase orders. It is a quick reference to see if you have reordered needed supplies. You do not want to order materials only to find out you had already ordered them. Your supplies may be back ordered and they have not arrived. (Once I mistakenly ordered 40 quarts of red tempera

paint and no place to store them. Just try to see how much it costs to send back heavy tempera paint).

To this folder, add a sheet of lined paper for your wish list. I used a colored paper so it was very easy to see among the other papers. Every time I ran out of a material, or ran low on a material, I added the product to this list. Do not think you will remember everything you need when you order next time. Be careful not to keep more than one on-going list, *only keep this one.* This list stays as close to me as my grade book. I add to it regularly. Remember, if the list is not convenient to get to, you will forget to write things on it.

Of course, you do not have to order everything on this list, hence the title "Wish List." Who knows, someone may give you a nice donation, or your department may win some prize monies, or the school board may up your funds. I once had a windfall and I had two days to put in my request for supplies I previously was not able to afford. I had on my wish list a new spotlight. We were doing sculpture at the time so lighting was not on my mind, but by using my wish list, I was able to get the spotlight that I really wanted.

Tip 21: Keep a File Box on Your Desk for Your Folders

K*eep a magazine file on your desk that will hold only the most used or most valuable folders.*

Here is what I keep on my desk right at my fingertips:

1. Art course syllabus: This folder holds my current and my past year's syllabi. I like to glance at what is ahead in the course. I like to review what I taught in the past year in case I need to make a last minute adjustment to what I will teach.

2. Daily attendance report: Every school will issue some kind of school wide daily attendance report that will record the absences, check-ins, checkouts, and tardiness from the preceding day. You should keep these in order as they come to you. You will be required to adjust your classes' attendance with the office's record of attendance. If there are discrepancies, you are required to find the problem. Here is an example: The report shows that Brad Pitt checked into the office at 9:00 a.m., you see on your records that Brad was not in 2nd period Art during that time. Where was Brad? Maybe he decided to skip your class, go smoke a cigarette in the student parking lot, and then go to his third period class. You will need to report his absence to the office.

3. Substitute folder: This will include pertinent information for a substitute teacher to follow in case an emergency arises and you need someone to teach your classes for one

to five days. All schools require you to have one. Take a lot of time to prepare the file defined by your principal. Include at least ten assignments that *anyone* could teach. Make sure some assignments are very short and will take 15 to 20 minutes. Choose other assignments that will take one class period to complete. Remember, you may have a different substitute on each day you are absent. If you prepare these assignments carefully, you will be able to use them for years. What will change will be the student roll, class schedules, and your duty assignments. If you get a phone call informing you that a close family member has been in a serious car wreck in another state, you will not give a hoot about your teaching duties. All you will do is get your car keys and bolt out of the school after you rush past the principal's secretary giving her vague information about where you are going. Do not burden yourself with having to make long distance telephone calls to the school two days later as you try to pull assignments out of your stressed and foggy brain. *Students get assignments to do whether or not you are there.* Plan ahead! Do not let this job fall on the teacher next door or on an assistant principal. That is definitely not the way to make friends and good neighbors.

4. Finance folder: This is the folder that you previously made relating to money, which contains your art supply orders, purchase orders, expenditures, yearly budget, deposits, and your wish list.

5. Blank discipline referrals: Many schools will have a standard discipline form that you are required to fill out before you can send a student to the office. Keep a stack of ten of these in the file. You recall that I have my own note

that I send to the office along with the student. In other words, you may be sending two forms to the office.

6. Upcoming art contests and competitions: I constantly refer to this folder. I am forever on the lookout for student works that may fit the criteria for an upcoming event. The dates on these competitions are important because you and the students need time to mat art, shrink wrap work, and put the required information on the identification labels.

Thought Provoking Questions for Selecting
Substitute Teacher Assignments

Where can you find simple to understand assignments for a "non-artistic" substitute teacher to follow? It is very helpful if you can show an example of how the assignment will end up looking. Avoid making these too complex or the substitute will give up and will give the students free time to get into trouble. Do not require too many mediums to work with, because finding and storing art supplies are frustrating for "subs." Do not include assignments that will require the students to work in mediums that they have never worked with before. This may be a good time to assign art history assignments from the textbooks. Remember, you will have to grade assignments when you return or the students will not do them the next time you are absent.

List 10 assignments you could leave for a substitute to follow. You will fully develop these assignments on separate paper.

1.

2.

3.

4.

5.

6.

7.

8.

9.

10.

Tip 22: Keep a Calendar on Your Desk

K*eep a large, flat, twelve-sheet desktop calendar on your desk.*

I would write notes on this calendar *all day long*. Sometimes I simply wrote little reminders about the next day. Often, the principal will come on the speaker with important information about last minute meetings that we must attend. I might receive information in the mail about a summer workshop that I do not want to miss. Maybe I need to write down a note about what I have to do during my planning period that day. I keep all of my scheduled lunch duty, recess duty, and athletic gate duty on this calendar. I mark special meetings I must attend on this calendar. Even a last minute substitute teacher in your class will appreciate knowing what extra duties they are expected to attend to. And at the end of each month, I put each used sheet on the bottom. I referred to them often to remind me of past events and dates.

If this calendar is not easy to write on, you may forget to note important events. If you forget to show up at your assigned duty station, your oversight is noted. I know from experience that if I brace the doors by myself trying to keep one-half of the student body from leaving the cafeteria before the bell rings, I am livid! Where was the other assigned teacher? "Oh, I forgot about it because I was busy," your partner may say. Their forgetfulness will make you angry, feel more used and more exhausted. So be sure you pay attention to your obligations.

Tip 23: Keep an Organized File Cabinet

K*eep a file cabinet to hold lesson plans, extra handouts, small examples of art demonstrations, tests, and inspirational pictures.*

A good, heavy file cabinet is your best friend. Usually, the school will provide you with one. If you change jobs, you will just need to remove your files and store them in boxes. I preferred to store files in copy paper boxes because of the cut out handgrips.

After I taught a project, I put its lesson plan back into the manila folder I had created for it. Once I have taught that assignment, I usually have extra material that I want to save. I might have 20 extra handouts to save. You will certainly have rules regarding the copy machine. Either the school will give you a user number that keeps track of how many copies you make, or the school will charge your department a fee for copies you make. You cannot be careless with the copy machines.

Occasionally, after I do a teacher demonstration for the class, I will keep that example to assist me the next time I teach the project. It is wonderful seeing how an old demonstration sheet will jump-start your memory.

If you required several exploration sessions using a new medium, be sure to save student examples to show different approaches to the new medium later.

If you write tests or reproduce tests from textbooks, include the test with the file on the project. Be sure to include an answer sheet along with the test. I write my answer sheets in red so I can easily recognize them.

If you find magazine photos that reinforce what you are teaching, include them in the folder. I love to use pages from *American Artists, Art News, Artist's Magazine*, along with *School Arts Magazine*. These are my favorite inspirations.

Tip 24: Arrange Student Tables or Desks

*A*rrange student tables in a large square or a rectangle. Leave two separate openings into the center from which you can walk around to conduct your general classroom teaching.

Teacher's desk

It is important to be able to get into the center of the room and immediately grab your students' attention. I do not place students on the inside of the tables. Everyone faces *into* the center. This allows extra desk space for their materials. It also prevents me from talking to students' backs! Have these tables arranged on the day before you start the term.

I love to stand at the center and hold up each student's in-progress work to let the students see the work from a distance.

I like to sit in my rolling chair in the center and call on each student to hold up their work for *me* to make short suggestions, or for me to ask short questions about the work. If you have individual student drafting desks plus a big room, well, lucky you. With those, you can face the desks all to the front of the room where you can place your desk.

Tip 25: Buy and Store Art Supplies

W hen purchasing your basic supplies, buy the best quality you
can afford. Thoughtfully plan where to store these supplies.
Materials should be easily accessible by everyone in class.

Here are ten suggestions for purchasing, storing, maintaining,
and organizing your basic art supplies and equipment:

1. **Buy the best paintbrushes that you can afford.** This
 does not mean buying top of the line professional brushes,
 but the best of the "school quality" brushes. Each year, I
 would buy a small set of new brushes as an experiment to
 see how well each set holds up.

 For my Beginning Art students, I do the following
 before they do their first painting assignment. I set up
 a painting demonstration. I lay out a medium, round,
 soft bristle brush and a cheap plastic flat tipped brush
 that comes free with elementary watercolor sets. I have
 a student draw some lines and a shape and then repeat
 them at the bottom of the paper. I ask the student to
 paint the first set using the plastic bristle brush and then
 paint the second set using the soft bristle round brush.
 The student laughs as he struggles with the plastic bristle
 lines and shapes. When he paints with the soft brush, I
 ask him to apply gentle pressure and let up and see the
 delicate variations that he can create. The whole class
 gathers around this student watching his trial. I have
 the student gently snap the plastic bristle brush over his

water bucket and ask him to look at the tip of the brush and describe if it looks any different than it did while it was resting in the bucket. "No", is his answer. I ask him to snap his wet *soft* bristle brush over the edge of the water bucket and look at the brush tip and describe what he sees.

"I see that all of the bristles come to a tiny point at the tip, and the plastic brush bristles did not move at all," he explains correctly.

"Which brush do you want to paint with?" I ask.

"The soft one because I will have a lot more control with my paints," he says.

I lovingly pick up his good brush for the class to see and I get a large sheet of paper for my demonstration. "This brush has been carefully set so that when you gently tap it against the bucket, all of these bristles gently cup inward and the longest strands are in the center. Watch all the different kinds of marks and lines I can create with this one little brush." I grandly and with dramatic flourishes make all kinds of marks with the little brush: thick, thin, curved, dots, blobs, comets, spatters, and long, graduating changing lines and even some Chinese Sumi-E paintings of bamboo and calligraphy chops. The students begin to get excited and they want to paint too.

"So, who wants to do their painting with the plastic bristle brush?" (The students step back in horror.) "O.K. then, let me show you how to clean this brush and where you are to store it at the end of class." We walk over to the sink and I show them. Next, I call on one of them to repeat my steps for cleaning the brush to see if they understand.

When we are finished, I discuss with my gathered students that this one little good brush costs four times as much as the plastic brush. I have enough of the good ones for every student to use. "There is a catch though, if you are not able as a group to take care of these fine brushes, I will be forced to give you the plastic ones. I can only buy these brushes once every four years." *The students now treasure the brushes.* I store paintbrushes, organized by size, in the drawers next to the sinks when we are not painting. In the weeks that we are painting, the brushes are cleaned, gently reshaped, and stand bristle ends up in opened containers on a drain board next to the sinks.

2. **Store rolling rulers, aluminum rulers, triangles, safety compasses and other measuring tools in a clean area away from art mediums.** Paint, pastels, charcoal, and inks will stick to your clean drawing tools and easily transfer onto other student's works. Oh my, if you ever see the look on a student's face when he discovers a smear of oil pastel on his highly detailed graphite drawing, you will not quickly forget it! I liked to remind the students to assume their tools are dirty and to clean them with a paper towel before they use them, nonetheless, store these tools away from transferable mediums.

3. **Store tempera paints away from acrylic paints.** On many occasions early in my career, I had problems with these paints being mixed together by unknowing students. The quarts of both look similar, and the weight and look of the paint is similar. It is an easy mistake to make. Imagine how a painting looks when these two paints are

mixed half way through the assignment. Another problem
deals with the paintbrushes. A student could leave out a
brush with tempera on it for thirty minutes assuming that
he only need water to reactivate it. It is only later that he
discovers that the brush is as stiff as if Elmer's glue dried
on it. It will be time consuming to clean it now and the
harsh cleaning is bad on the brush.

4. **Order good tempera paints by the liquid quart and
 create sets of colors on each table. Provide individual
 mixing palettes so students can store their paints from
 day to day.** It is extremely important to find a tempera
 paint brand that you like to work with. When you find a
 brand you like, make reference notes about the company
 that sells it. The next time you need tempera, buy the
 same brand. Some tempera paints do not mix chemically.
 I have tried to mix some brands together, and that created
 a gritty paint that defied all reason! I had to shut down the
 painting project until I could reorder paint in one brand
 only. Another problem is that primary colors are not the
 same from one company to another. Imagine how awful
 skin tones look when the colors change half way through
 the painting. Yes indeed, this has happened in my class
 too. I like the black wire caddies that are designed to hold
 six quarts of paint. I would place a set out for students
 from each table to share.

 My Beginning Art students each get a foam dozen
 eggs carton to place the twelve colors of the color wheel.
 These twelve colors are to stay pure. I have large cabinets
 where the students store and stack these cartons by class
 period (with their names on the top and ends). As one

runs out of their twelve colors, the student replenishes the wells from the quarts.

Each student, in addition to having a foam egg carton, is issued a round mixing palette and a plastic lid with a permanent number written on the top and bottom. These are also stacked and kept from day to day. In these palettes, custom colors are created by using the colors transferred from the egg carton and blended with the black and white tempera. These can be worked from for weeks on end. At the end of tempera painting teaching units, each student cleans, dries, and returns their palette. The egg carton colors, when sprinkled with water, stay fresh for weeks. I allow the students to take home the egg carton paints they mixed.

Probably your biggest waste of money will be on paint poured down the sink. Plan carefully and order the best paint you can. Create a place where each student can store his or her custom mixed colors. Be sure each student knows exactly where his or her paint is to be stored. Planning in this way will ensure that each painting class will begin and end in a pleasant and orderly way and your students won't be frustrated by trying to match colors from day to day.

After tempera-painting assignments are finished, the egg cartons are removed and the paint palettes and lids are returned, we use this now empty storage cabinet for small "Sculptures in Progress." This storage system has never let me down.

5. **Keep your graphite pencils, erasers, and other graphite supplies separated from your charcoal supplies.** The

same way tempera and acrylic paints look alike, so do charcoal and graphite materials. Graphite and charcoal mix like oil and water do. It is a very unattractive combination. If a kneaded eraser is used just one time on a charcoaled surface, the eraser can never be used again on a graphite surface. If a student mixes charcoal pencils in with your graphite drawing materials, the black dust will transfer onto everything!

6. **Keep all types of glues, epoxies, hot glue guns, glue sticks, masking tapes, and clear tapes in the same storage area.** This is a well-used area. It needs to stay clean and dry. Think of this area as, "Things used for attaching or sticking."

7. **Store empty buckets, mixing containers, cleaning supplies, sponges, and clothes spot cleaners under the sinks.** If something is used for "diluting", it will be kept under the sink. If one drips anything down here, it will not matter one bit.

8. **Ask your school janitors or a maintenance person to keep you stocked with a supply of large trash can liners, paper towel refills, and a gallon of liquid soap.** Some days, you will need extra bags or cleaning supplies on a moment's notice and you may not be able to locate someone who has access to the school supply room. Find a place to stash these extra supplies. Do not forget to remember the name of the person who is responsible for cleaning the art room every day. Get to know this person. Be sure to give this person a Christmas gift. Be sensitive

to their responsibilities to others on your hall. You will want this person to be happy to help you when you have maintenance problems in the classroom. The maintenance team is as important to you as the principal's secretary. They report what they think and hear about the teachers. You will certainly want them to be willing to work with you.

9. **Make plastic labels to identify what supplies are behind the cabinet doors.** Because I carefully planned where to store my basic materials, I do not change their location from year to year. This is particularly advantageous to your Advanced Art students. You will not be interrupted with as many questions about where supplies are located. Your students are more likely to return materials to where they belong if you have clearly identified where you want them to be stored.

10. **All drawing, printing and painting papers should be stored in a separate room if possible. Keep cut mats, matting boards, construction paper, cutting boards and tables in this same area.** It is a ghastly thought, but one student could ruin a whole ream of 24x36 inch heavy Bristol board just by running dirty fingers through the paper. This is why *I* went into the storage room and *I* brought out the paper for each assignment.

Order a wide range of paper, from the cheapest newsprint to a wide variety of different textured surfaces and weights in a wide range of sizes. Paper is a delicious sensory exploration for your students.

I allowed no one to use the heavy handled cutting board without my personal instructions and then I require that the student using the cutter do a demonstration for me. This is a dangerous tool and access to it is controlled. I have heard of a story about a student who lost his fingertip while cutting on a board. Who wants a lawsuit brought against them for lack of supervision of dangerous equipment? I certainly do not.

Thought Provoking Questions **about**
Rearranging Your Supplies in Storage

Look back at the ten suggestions. Look at your current art room and decide if you would benefit from rearranging some of your supplies. Write your ideas for each below:

1. Where can I store unused paintbrushes?

2. Where can I store measuring tools?

3. Where can I store tempera paints and acrylic paints in separate areas?

4. Where can I order wire paint caddies and where can I store them?

5. Where can I store extra graphite supplies?

6. Where can I store hot glue guns, tapes, and glues?

7. What is under my sinks other than buckets and cleaning supplies?

8. Where can I keep extra garbage bags, a gallon of liquid soap and a case of paper towels?

9. How can I make heavy duty, waterproof cabinet identifications labels?

10. Where can I keep clean paper away from dust, grime, and liquids? Where can I store unused mat boards? Is my paper cutter located in a safe place where I can control its use?

Tip 26: Keep a File for Your Favorite Quotes

K *eep a file to hold your collection of favorite quotes*

In 1973, I bought a small paperback book called, *One Hundred Ways to Have Fun with an Alligator and One Hundred Other Involving Art Projects,* by Norman Laliberte and Richey Kehl. It was a hippy-designed book unlike any other on the market at the time. This was my first exposure to famous quotes that related to artists specifically and I enjoyed this jewel of a book so much that it's now a hundred little brittle pages in a zip locked sandwich bag.

I began writing a list of my favorite quotes early in my career and I kept them in a file. Unfortunately, many of these quotes are anonymous. Regardless, they are effective. I made copies of my collection for students and I have used them as inspiration for many types of projects. I used them for poster ideas and as calligraphy projects. I used them to stimulate class discussions and debates, and as springboards for independent projects. Here are a few of my favorites:

Everyone wants to understand painting. Why don't they try to understand the song of the birds? Why do they love a night, a flower, everything that surrounds man, without attempting to understand them? Whereas, where painting is concerned, they want to understand.

Pablo Picasso

Beware, as they say, of mistaking the finger for the moon when you are pointing at it.

<div align="right">Anonymous</div>

"I'm looking for a key I lost over there."
"Why not look then, where you lost it?"
"It's too dark over there. I look for it here where there is light."

<div align="right">Anonymous</div>

People who look through keyholes are apt to get the idea that most things are keyhole shaped.

<div align="right">Anonymous</div>

Though we travel the world over to find the beautiful, we must carry it with us or we find it not.

<div align="right">Ralph Waldo Emerson</div>

Be willing to paint a picture that does not look like a picture,

<div align="right">Robert Henri</div>

Computers are always right, but life isn't about being right.

<div align="right">John Milton Cage, Jr.</div>

"Our creations are in the first place ourselves."

<div align="right">Amédée Ozenfant</div>

Tip 27: Have Enough Smocks or Aprons
for Each Student in Each Class

O *rder denim smocks or aprons for one class. Drape them over a sturdy coat rack when not in use.*

The use of aprons has proven to be the most cost effective way to prevent ruining students' clothes. I like denim aprons with a loop at the neck and two tie strings at the waist. These will adjust to fit any size student. I wash the aprons twice a year. You may have to repair torn waist ties. I could usually find a student in consumer science to make these repairs on a sewing machine.

I kept about thirty aprons. A student's father, who was in construction, volunteered to make a sturdy rack, built from heavy pipes. Your apron rack needs to be strong so it will not tip over or slump from the weight. The rack that this parent made for me had a top pole about four feet off the ground. The length of the bar was about four to five feet. Because your aprons will have long ties, the height of the bar is important so the ties do not drag on the floor.

I give a demonstration on use of the aprons. You are probably thinking that I am going to say something to the students about the purposes and care of the aprons. Right you are! I might even describe an awful experience by a student who mishandled his apron. These demonstrations and descriptions will stick in their minds and will help them take responsible actions, even when you are not standing over them, watching.

Once the students gather around me, I begin my demonstration. First, I put on the apron to show how adjustments can be made

for comfortable wear. I make a shoe type bow at my waist and then I pull the string to untie it. Next, I redo the tying, but this time I make a knot. I ask a student to help me undo this knot. The student fumbles and gives up and asks another student with fingernails to help him undo my knot. After much aggravation, we finally untie the knot.

"Now students, we see that making a bow tie is important. What will happen if we couldn't get this knot untied?" I ask.

"I guess I would have to rip it off because I am not going to Algebra with that thing on!" a student blurts out.

"I don't blame you," I respond. "But if you rip these ties off, no one else can use it because the apron won't stay in place to protect their clothes. Then I expect you to take the apron with you to have it repaired. Would you all agree that this is fair?"

"Yes" they nod to me.

"You can imagine that it is difficult if you are the last one in class and all of the good aprons have been chosen. You will have to be extremely careful if you want to protect your clothes. I don't want you to be distracted by worrying about your clothes."

One final demonstration: I wipe a big, thick blob of acrylic paint on the front of an apron. Next, I put it on *backwards* so the wet paint could rub against my clothes. The students take a deep breath. I am ever so careful not to actually let the blob touch my clothes, but they don't know this.

"*Never put an apron on backwards; the inside must always remain clean.* You can see what will happen to your clothes," I declare rather strongly. "You defeat the whole purpose for wearing the apron if you do. You do not have to wear an apron. It will always be up to you. You do not have to ask permission to wear one, just get one and return it properly at the end of class.

"Now, one last request: "*The aprons are not your paper towels!*" The class will laugh as I wipe another *big* blob of paint onto my hands. I look at my hands and say, "Yuck, what do I do?"

"You wipe the paint on a paper towel and not the apron!" they call out.

"You are absolutely right, students. It would take *days* for this blob to dry! How would you like to be the next person to use this apron? I can see it all now: There you are, finishing up a pastel drawing, and with no warning at all, you smear paint on your drawing! And there you sit, wanting to rip someone's head off!" I make an absolutely disgusting face as I pretend to look down at the imaginary ruined art and the offending apron. The students roar with laughter at my imaginary anger and frustration. I dismiss them back to their chairs and the demo is over.

Oh, yes teachers, this all sounds excessive to describe all of this in such elementary or even in insultingly simple ways. I felt the same way in my first few years of teaching. With experience, I learned what needs to be "spoon fed" to the students. This is one good example. After this ten-minute "performance," I never again had to talk about the aprons. Your students will retain a mental picture of your demonstrations. And maybe, just maybe, you will not have to repair ties or throw away costly heavy-duty aprons at the end of the year.

I would much rather spend our money on exciting art materials, wouldn't you?

Thought Provoking Questions **about Providing an Apron for Each Student**

Think about a time at the end of class when *most* of your students left the classroom covered in messy art mediums. Some of the students will mumble about wishing they had not chosen to take art. Gleefully and purposely, some students will rub their messy pants across the hall walls, leaving a *long* trail. Imagine some parents that evening who will be distressed that their child's last good pair of pants is ruined. Maybe the parents are not able to buy a new pair in time, for example, the band concert their child will be in tomorrow. Think about the sacrifices parents make for their child's clothing.

I *cheerfully* took pride in often being a slob in art classes in college. It was rebellious and I felt it gave me the illusion that I was a "passionate artist." It was a positively delightful feeling! However, try to view this issue of helping your students staying clean as we view drinking alcohol, we do not let children drink because they do not have enough life experience and mental maturity to handle it responsibly. Our students can be as messy as they want, once they have matured and have a respect for other people's property and they grasp the costs of replacement clothes for themselves and others.

Look in your art supply catalogs and find sturdy student aprons. How much does each apron cost? How many will you need to cover your largest class? What will be the total costs for a classroom set? Investigate who could build you a standing bar rack. (Or, better yet, hooks screwed into an available wall). Will

the supplies needed for construction have to come out of your
art budget?

Write below some of your plans and ideas on aprons for your
class.

Tip 28: Keep the Art Room Orderly Throughout the Day

C *lean your room at the end of each day.*

If the room is not clean by the end of each class, it is hard to make the next class responsible for the previous ones. Yes, yes, yes. I know you are beginning to raise your eyebrow over this whole "clean" issue. And I promise you, this is the end of this topic. Art is messy, it is joyous, it is passionate, and one should get lost in its purging of the soul.

Nonetheless, your classroom environment can cave in within a matter of days if you do not follow a system, such as my Monitor System, to keep things orderly. Every student deserves to come into a clean space to do his art. Your students count on knowing that there is a special place just for them to make their ideas tangible. It is comforting to the students and that comfort will *foster* their freedom to express themselves.

I have walked into classes taught by inexperienced art teachers and seen what happens to that last class of the day: unruly, unchallenged, irritable underachievers. Oh, of course there will be those exceptional students who can block out all of the distracting puddles on their desk, smears, bits of clay, dots of wet glue, wet paper towels, and slippery floors. Broken, misplaced or unavailable equipment and clogged sinks will only be a slight bother to slow them down. But really, how many students are we talking about that can do this? I would expect about seven teenagers out of a class of twenty-five can work well in these conditions. Do not lose sight of the fact that you were hired to teach art to *all* of

these students. It is easy to fall into the familiar mindset we see too often: "Those students are so awful and so uninterested in art that I have decided that I am only going to teach those few who have a real interest." I have frightening news for you: If your administrators hear you say this, you should not be surprised if they do not ask you back to teach the following year. You were not hired to teach the easy students. You were hired to teach every student on your roll. One way to achieve this is by keeping your room clean and orderly.

CHAPTER 3: FINANCES

Tip 29: Focus on Your Role as an Instructor

*D*o not let a small budget and fund raising projects steal your energy from your first and foremost job. You must keep in mind the six National Goals and Standards set by the National Art Educators Association that you should be addressing: art materials and process; aesthetics; subjects and themes; art history and cultures; criticism and evaluation; and interdisciplinary connections.

Some states, districts, or cities are supportive of the visual arts. If yours is, you better be producing one heck of an interesting program, because you owe it to us who do not have the advantages that you have. Other districts will offer only what the government demands to be offered. How much money allocated to ones visual arts program can be dismal.

If you focus only on what you want and not on what you have, you may be neglecting your job as a one-on-one instructor. A whole art course could be based on using cheap supplies like copy machine paper, #2 pencils, ball point pens, tempera paints, large newsprint, one classroom set of paint brushes, and paper mache. Donations of left over products from local businesses is an easy way to add materials. Printing companies usually have boxes of colored paper in different stocks and textures that they cannot sale. Some of my favorite projects are on beautiful and unusual paper that I never could have afforded to buy, much less even thought about trying it out. A good teacher can find creative ways to present important concepts.

Now, if you are a dynamo and blessed with a body that can get by on six hours of sleep a night, by all means, organize

huge fundraisers. Do not let *my* limitations stop you. Set the art community on *fire* with your energy and passion! However, if you remember, my goal for writing this book was to offer advice on how to reach *retirement* teaching art. I do not want you to lose your job, be less than a spectacular teacher, or have your family fall apart all due to your neglect because of exhaustion from fundraising. It is a lot to manage and sadly, many of our finest do not make it. *Learn to pick your battles carefully and learn to manage your time and your budget efficiently.*

Think about where you would draw the line when it comes to fundraising. Would you sell students' donated works at an event to buy classroom art supplies? Would you sell mugs and candy to buy new tables? Would your Art Club sponsor a dance to buy a new paper cutter? How will you pay the police officers that are required to be present for all dances? Would you have students sell carnations on Valentine's Day to buy a new printer? Would you create and sell tee shirts and use the profits for a field trip to an art museum? What do you do with the unsold tee shirts? How do you keep the receipts? How do you, with the office bookkeeper, manage the ledger of the money spent and collected? Money cannot stay in your classroom overnight. You must turn in all monies collected to the office and an independent accountant will audit it at the end of the year. You will get into *huge* trouble if you do not show exactly how you collected and spent every penny!

Write your thoughts on the issue of fund raising to pay for your supplies in the space provided below.

Tip 30: Order High Quality Art History Visual Media

Y ou should order only high quality art history video media for the class. Poor quality images can turn off students.

Grainy images and inaccurate, muddy colors from the video media will create disastrous results for what you are trying to accomplish in showing the art. Visual art is *visual* and by golly, your visuals had better be good! Wait until you can afford to buy high quality video media and equipment. When you order video media from the School Board, be sure to preview them. You will want to check for clarity, for color quality, and for *inappropriate* images.

Tip 31: Order High Quality Technique Visual Media

O*rder good quality technique videos and DVDs to help round out your own teaching style.*

My classroom video library was rich with videos of technique demonstrations. My classes and I greatly benefited from them. Here is your opportunity to strengthen the skills you missed in college. Other instructors have different approaches to themes, mediums, and tools. This is a very good thing. My favorites on techniques deal with light logic, pastels, watercolors, calligraphy, colored pencils, pen and ink, and graphite techniques. Use the school system's lending library. Check out videos for viewing over the summer and make a list of the ones you like and that are appropriate for the grade levels you teach. Keep permanent notes on your reviews of these videos because it is easy to forget what you have seen.

Tip 32: Provide Supply Boxes for Beginning Art Students

H*ave a supply box for every student table, filled with pencils, erasers, or other graphite materials. Write a number on each box and a corresponding number on each table.*

I did this each term before my new students arrived. It became part of my room preparation duties. I liked to order plastic, snap lid boxes that measured approximately 10x6x3 inches. I had to replace them about every two years. If my classroom had twelve tables, I needed twelve boxes.

I used regular whiteout pens to write a one-inch high *Table 1* in the upper right corner of the first box. Using the same whiteout pen, I then wrote *Table 1* on the upper right corner of the first table in the room. Go around the room and identify each box with its table. The whiteout on the tables does not easily come off when students clean the tables

This system holds the students accountable for their supplies. If one knows he has to work out of the same box every day, he will take better care of the box. Everyone has an assigned seat every period, so it is easier to hold others who sit there accountable for missing supplies.

When I introduced the new students to their table supply box, I described its contents as dental tools. The dentist needs different tools for different purposes. Each tool has a specific purpose and specific maintenance and cleaning procedures to maintain each tool.

These boxes include the following materials:

- Two (2) H pencils
- Two (2) HB pencils
- Two (2) 2B pencils
- Two (2) 4B pencils
- Two (2) Ebony pencils
- Two (2) small kneaded erasers
- Two (2) pink pearl erasers
- Two (2) white vinyl erasers
- One (1) sandpaper pad
- One (1) pencil sharpener with a snap on shavings case

Give each student a piece of paper to experiment with using the supplies.

When I do this demonstration, I draw a graphite scale on the board, explain how H lead pencils are hard, and make very fine, light, and precise lines. I explain how B lead pencils make dark, thick lines. I explain that the larger the number the more exaggerated the line quality. For example, a 4H pencil is lighter than a 2H pencil and a 4B pencil is blacker than a 2B pencil. I explain the smeary black quality of the Ebony pencil. I give them this opportunity to practice and see for themselves. Have the students try layering different leads over each other in slightly different directions and see the differences this creates. I demonstrate why and how the three different erasers are used and I give them a chance to try them out. On this first day, I am training the students to respect and enjoy the array of fine materials I have provided for them. I demonstrate how a shadow on a cheek is much more beautiful if I use the kneaded eraser than if I use the pink pearl. I demonstrate how to stretch and clean the kneaded eraser. They love how the graphite

just disappears. I demonstrate how the pink pearl can take out the deepest, darkest marks yet it can rip the paper with its rough grit. I show that by rubbing an eraser on sandpaper, the edges become clean and crisp again, and prevent smudges to get all over their drawings. I demonstrate the smooth erasure marks that the vinyl eraser makes and how, when it is turned on its side, very straight erasures can be made. All of these materials will give their drawings a professional quality they have never been able to produce before by using just an old #2 yellow pencil.

I would explain to each class that by providing these kits, I never had to worry about a student not having drawing tools in class. I had more important things to do. The materials in each box are paid for out of their art fees. If they disappear, well, they just have to use the leftovers in the box. (Unless I have extra supplies to replace them). Their fees had already been budgeted for paints and sculpture materials. If I spent all of their fees on replacing graphite supplies, they would never get a chance to use some really cool art materials.

This may seem like a lot of effort, but I have a reason for all of this. You see, *now* the students will not be making spit balls out of the kneaded erasers and sending them across the room like a semi-automatic rifle fire. The shooter will receive ice-cold stares from his classmates even if I did not see it happen! *Now* the students will not laugh when a kid throws a pencil away into the garbage can. *Now* a table partner will not think it is funny when her partner bangs their pencils on the side of the table, like a heavy metal drummer, breaking up the lead inside of the wooden casing. Be smart. Think ahead and anticipate bad or naive behavior. *You have to train and explain before you can expect your students to make smart decisions. Help your students think about the consequences of their actions before they do something stupid.*

Tip 33: Issue Art Kits to Each Advanced Art Student

I ssue an art kit to each Advanced Art student to use for the entire course. This kit is returned at the end of the course and checked by you for any missing materials.

Sanford Art Supplies makes a very fine art kit. This is what I liked to use. Each black box has a snap top lid, cushioning inside, and measures about 12x5x3 inches. Either order one already filled or make your own. Fill it with various graphite pencils, erasers, a sharpener, colored pencils, graphite sticks, and even markers, if you have enough room. Your students will need this to complete their sketchbook requirements; they should all have equal access to good materials. When you check each kit's contents at the end of the course using a checklist of everything that was in it when the kit was issued, you will find that each kit will last you for five years. Clearly explain to the class that if the kit is lost, the student will have to pay for it. If some of the materials are lost, they will have to buy those missing materials. Of course, you must replace *worn out* supplies from your art budget.

Getting an art kit is a badge of prestige for all new Advanced Art students. They look forward to receiving it. They carry it around everywhere with their sketchbooks. It says they are "real artists."

Again, as with the art boxes left on the tables for Art 1, each kit has a number or identification on it. I used whiteout pens, just as I labeled boxes and tables for my Beginning Art students, but you might try an engraving tool. Include the best supplies that you can afford and then require that the students take good care of them.

CHAPTER 4: LESSONS AND GRADING

Tip 34: Recognize How Formal Lesson Plans and Assignments Differ

U nderstand that the lesson plans that you turn into the office are not written the same way you write assignments on the board.

In your college education courses, you learned how each instructor wanted a lesson plan written and the correct words and terms to use. Good. You will probably need to write *student objectives*, which typically begin with "The student will...." The school board you work for will determine other components in a lesson plan. One will usually have to provide five days of lesson plans a week in advance for every week of the teaching year. A lesson plan may cover a project that could take weeks to complete, or cover a project that may take one day.

I have the unusual honor of having *two first cousins* who are fabulous high school art teachers: Kim Nall and Renee McNeil. I've asked both of them about their respective school system's lesson plan guidelines. Renee's school is having all teachers document in their lesson plans what state standards are being taught in each class, Kim does not have to include this. They both teach in the same state's public schools.

In the following pages, I will explain and show you how I use my boards to tell each class what the assignment is and what I expect of them, what my role will be, and where we are in the project. To make your day *easier*, this is the systematic route through the project and is the practical part of a lesson plan.

Tip 35: Write Daily Assignments on the Board Everyday

*W*rite *your daily assignments for your projects on the board every day. As one of my middle school principals once told me, "If you can't write it simply and clearly, you don't understand what you want the students to do.*

Well now, that sounded insulting to me. Mr. Magee stood there at the board and made me rewrite my assignment on the board for that day. I wrote my *motivations*, my *instructions*, the *procedures* and *materials* the students will use in their next class period. He made me rewrite everything until he could follow my logic without having to ask me any questions. I struggled with my words until it was very clear and he was satisfied. Until one can write it, one cannot explain it. Of course, in art we teach many "fuzzy" concepts, even more reason for you to be diligent in writing your plan on the board. Your plan should always be clear and easily understood.

When I was teaching, I would divide the board into a left side and a right side. I put all projects and deadlines for Art 1 on the left half and all projects and deadlines for Art 2 and 3 on the right side. By keeping information in a predictable location, your different classes automatically know where to look when they enter the classroom. At the top, I would write the day of the week so there is no confusion about what day I am talking. Under that, I would state if we are beginning a new project, assignment, or lesson. I then list the "how's and what's".

In the afternoon, before leaving school, write the next day's assignment under the current day's assignment, then place check

marks to the left of each completed procedure in the assignment. This is important; you will have to start tomorrow's assignment at the next unchecked procedure listed on the board. In other words, keep two daily assignments on the board for each course you teach: the previous day's assignment and the current day's assignment. You may be ahead or behind from day to day, but stay on course with your lesson plan.

As I have said, I am not an early morning person. Besides, in the afternoon, the day's work is still very clear in my mind and I can write a better assignment. I never left school until I wrote tomorrow's assignments on the board.

When I left for the day, I didn't fret over the next day's assignments. I didn't need to, because when I walked into class the next day, *the assignments were already on the board.*

Example: How to Develop Daily Assignments

When writing a daily assignment, I was always careful to consider the following five topics. They do not always follow a specific order, but what I write on the board for me and the students to follow is determined by these topics. I make a list of everything I will do and what they will do during the class.

Art 1

Introduce new project
(Describe the new project or assignment to students.)

Motivation
(Review what the class did yesterday). Ask students questions to help them focus on what they have been doing. Will today's assignment relate back to yesterday or is this new, unrelated material? If today you are introducing a new project, say a value shading of sea shells done in charcoal, you will want to get the students excited about the new project. Show examples of past projects done this same way. Show examples of charcoal drawings and discuss what is unique and special about charcoal. Discuss the textured and beautiful papers needed for charcoal and how delicate are the laid lines in the paper. Discuss how white charcoal will show up on the softly toned sheets of paper in a way graphite would not. Show examples of charcoal drawings done by well- known artists.

Instruction and Demonstration

You will need to do teacher demonstrations of what you want the students to do for the day.

Student Procedures

Write, in a list, what the students will do today. You can number these or draw a bullet to the left of each one. As we finish each of the procedures, I put a check mark on the board next to it.

Materials

Write on the board the supplies needed for the students to do the procedures. Where will the supplies be located? Will the monitors hand out supplies or are the students to get them themselves? Are the supplies to be left on the table at the end of class or will the monitors collect them? Write all of this on the board. This is the end of your daily assignment.

Example: **How a Daily Assignment Will Look on the Board**

Example of a daily assignment written on the board. Note that I very specifically indicate who is responsible for which portion of the assignment by using the headings "Mrs. Johnt," "Monitors," and "Students." This way, everyone knows exactly what is expected of them:

Art 1

Mrs. Johnt
- Collect late projects due from yesterday's deadline.
- Introduce our new project: charcoal drawing of sea shells.
- Show examples of past student charcoal drawings
- Show paper and charcoals that students will use.
- Show difference between charcoal and graphite
- Demonstration: white charcoal on toned papers
- Demonstration: drawing with vine charcoal and using a blending stump.
- Create textures and patterns with vine and a stump.

Monitors
- Hand out full sheet of newspaper, practice sheets of toned paper, one vine, and one stump per student

Students
- Place a full sheet of newspaper under the toned paper.
- Practice applying vine charcoal and blending with a stump, as shown in the teacher demonstration.

- Practice adding vine lines over blended areas
- Practice making dark and light lines in thick and thin marks.
- Create and number ten textures or patterns using vine and blending stump.
- Put the practice paper into your shelf. Gently fold and throw away the newspaper. Tomorrow you will use the same practice sheet.

<u>Monitors</u>

Collect vine and stumps seperately and clean off tables with sponges.

Clean sink area and check floor for supplies and trash.

Push in all chairs.

See Mrs. Johnt before leaving class to receive your daily Monitor grade.

On the bottom area of the board is where the project due dates, along with how you will grade it will be written (see Tip 36). This information will remain here up to a week.

Tip 36: Write When Projects Are Due and How They Will Be Graded

W rite on your board, under your assignments, when projects are due and how you plans to evaluate the projects.

Here is how one of my project deadlines and grading guidelines look:

Art 1, 1st and 3rd Period

<u>Charcoal Drawing of Seashells</u> will be due upon *entering* class on Tuesday. If you have been absent or need more time, please see me to check out materials needed to complete the project on your own time. All assignments handed in late without a written absence excuse will be penalized 10 points for each day it is late.

To make a high A on this drawing you will need to meet the following requirements:
- Art work is handed in on time
- Student carefully observed actual sea shells
- Five textures have been created using vine and blending stump
- White charcoal is used only as final indication of strong highlights
- Visual unity is evident
- Originality
- Effort given

- Craftsmanship
- Elaboration

Students need to know *in advance* how you will evaluate their work. I do not want all the assignments to look alike, but some guidelines help to get what you want from all the students. Students are comfortable with preset requirements for grading. I hardly ever have to argue over a grade with students, parents, or administrators. *Communication about grading procedure is imperative before the students hand in their assignments.*

I feel a student should receive a grade from me about every week. Some weeks, I might have to walk around and give in-progress grades if I think the project will take two weeks to complete. Sometimes I announce that a finished project will count as two grades because of the length of the assignment. Just be sure to discuss your plan in advance.

Tip 37: Take Points Off for Incomplete or Late Assignments

W hen you collect work for grading, take points off for incomplete work or work that is turned in late. Running down assignments is a waste of your valuable teaching time.

Do employers want employees that cannot (or will not) hand in their paperwork or projects on time? Teachers hear regularly, "Can't you teachers send us people who can properly and completely fill out a form?" Of course, we can. We just need to set consequences that are strong enough to change students' sloppy behaviors.

Here is a common and draining routine you can get into: chasing down assignments to be graded and listening to creative excuses on the students' part. If students can talk you into accepting late projects with no grading consequence, word will spread like wildfire that you will take projects whenever the students want to turn them in. You will find yourself grading six different types of assignments *all day and every day*. You will forget what standards you used for grading a particular assignment. You will be distracted from the project you are currently teaching. When you are ready to average grades at report card time, you will find yourself staring at lots of blank squares of missing grades. *Allowing students to turn in late work without a grade penalty punishes you, and not the students.*

Tip 38: Make Signing Artwork Properly Part of the Grade

T*rain your students to sign their first and last names clearly on every assignment. Take off points, as discussed with each class, for projects improperly signed.*

I like signatures written in the medium used to create the artwork, if possible. Exceptions are watercolor and tempera paintings, which may be signed in pencil. A very large and thick signature written in watercolor or tempera paint is a distraction from the artwork.

My students sign their art pieces in the lower right hand corner on the front. The students leave a full inch on the right, past their last name, and leave a full inch below their name to allow for matting and framing. This will keep their signatures from being covered. So many times, I have seen one-half of a last name covered over by a mat. This is unattractive and certainly unprofessional looking.

Scribbling the name, in an effort to be original, is annoying. Once a student becomes famous in the art world, he can sign his work as he jolly well pleases, but try looking at a signature that looks like a Celtic knot on steroids and then try to decipher what that first letter is. You will be searching through your whole roll book looking for any letter remotely similar to the knot. Can you think of better ways to spend your time? Of course you can, but take five points off Knot Boy's project (once you finally, by a process of elimination, discover who he is). On the back of his project, write the grade he deserved based on his efforts, under it subtract five points and explain why you did: "unrecognizable

signature." He will remember next time to sign his name clearly for you (and for others who want to know who created the work). The good news for Knot Boy is that you are not going to hold a grudge against him because he paid a fair price for his sloppiness.

Tip 39: Divide Assignments to Be Graded into Three Stacks

*B*efore issuing grades for an assignment, go through the stack of projects to grade and get a feel for the overall quality of the work. Next, divide the works into three stacks: The best, the average, and the poor.

After I look at all of the projects to be graded, I go back and divide the projects into three piles:

1. The *best* of what you asked for out of the assignment, *as written on the board.*

2. The *average* works.

3. The *poor* pieces based on what you required and clearly communicated.

The topic of how many A's to give is certainly a hotly debated issue. By the time I retired, I was giving mostly A's and B's on most projects, but this was because I *forced* my students to do well. By walking around every day and reviewing their works in progress, I was able to prod them along at a good pace. The work turned in to me was really well done. One could accuse me of not letting the students manage their assignments on their own, but I do not see it that way. Because I stayed close by to review their work, all of the students stayed busy, and therefore, no one was creating distractions unrelated to the art assignment. Thus, they produced better work.

I will give you two scenarios that I experienced with two different assistant principals. One principal, at a Catholic high school for boys, called me in to discuss my grading. He did not believe that most students could be "above average." How were the exceptional students going to be recognized? He asked me to restructure my grading and give more C's and I did, just enough to keep him happy.

The next year, at a public junior high school, the principal questioned my grading, "How can you give bad grades for art? These kids cannot help it if they do not have talent. I would like to see you give higher grades for their effort." I did, but just a little, just enough to keep her happy.

No matter how you decide to issue grades, just be consistent. Your students should almost predict what kind of grade they will receive. In each class period, I give two students a perfect 100 on every project I grade. This is something all the students are anxious to discover. I give two 99's per class for those two students who were also exceptional. I will hold up all four of these projects and discuss what I found so appealing about each one. This is a joy to do and eagerly anticipated by all of the classes.

Special education students require an altered plan for grading their projects. You will usually have a few mainstreamed special education students in your art class. You will not place their projects into a sorting pile. You will refer to their Individual Education Plan, given to you by their special education teacher, to see what accommodations you need to make when you *give* the assignment and when you *grade* the assignment. If you need to lower the requirements for your special students, you must discuss this with each student and you *must* do it discreetly and with sensitivity. Give your students the dignity to feel comfortable and to *feel* they are the vital and important members of the class

that they are. I write on the back of their assignment my altered requirements so their special education teacher can assist the student, if necessary. Your special education students may have time to work on their art at home or in another time slot in their day at school. Special education students have created some of the most delightful, insightful, thought provoking, and refined works of art I have ever seen. We display their art on the walls, the halls, and in competitive art shows along with all of the others.

Thought Provoking Questions on How You Will Grade Art Projects

Give some thought to grading art. Many teachers feel differently depending upon the grade level they teach and their individual college teacher training. An elementary art teacher may very well do everything possible to avoid giving grades and I do not blame them. How do you feel about curving the grades in art so that most of the students fall in the bell curve of a C grade? How do you feel about giving all students an A for attempting the project any way they want to? Under what circumstances would you give an F on an art project? If a student is exceptionally talented, will you hold that student to a different standard? How low would you drop a grade for a special education student who could not understand, for example, one point perspective? Are you prepared to defend your grading procedures if the principal calls you in to discuss this matter?

Tip 40: Taking Art Projects Home to Grade

D*o not take work home to grade. Your home life is just that: your home life.*

You have a daily routine with your family or a personal routine that you enjoy. Arrange to get to school one hour earlier or stay one hour after school so you can grade, arrange the room, and plan. Make this extra time a standard operating procedure and you will reduce the stress level you feel away from school.

There are other reasons not to take art home to grade. Taking work home can (and will) ruin the art. How? Because pieces can rub together, tear on your gym shoes thrown into the back seat, and crease when your new novel falls on the stack of art. The wool jacket you are taking to the cleaners now has a bright red pastel smudge on it. Tiny oil pastel flecks are invisible until your nephew climbs in tomorrow and rubs them into the upholstery. The green tempera paint on the back of a painting has now transferred itself onto your kitchen tablecloth. Surely, you do not want to hear any more examples. *Do not take student art work home with you.*

Tip 41: Vary Your Assignments in Subject, Theme, and Style

Vary your assignments in subject, theme and style, such as: Realism, Abstractionism, and Non-Objective styles. This way everyone can reach a high level of success on a regular basis, and no one will get bored or frustrated with predictable subjects or themes in your curriculum.

Let us say that your personal strength as an artist is in oil paintings of landscapes. If all of your assignments lean towards your interests and strengths, some of your students will not get a chance to learn about what might interest them. So often, a student who is frustrated by self-portraits will excel when introduced to wire sculpture of woodland creatures. After an intense social comment assignment, a shy student may relax when given an opportunity to work in delicate watercolors of dragonflies and fairies.

Dr. Irene C. Glaser devised a wonderful model describing various ways to design different types of assignments.[1] Dr. Glaser suggests that *all* art projects include the six National Goals and Standards set by the National Art Education Association; below is the list of materials and processes I try to work with each year.

1. Art Materials and Process (including Health and Safety)
 a. Drawing—charcoal, pastels, pen and ink, graphite
 b. Painting—watercolors, tempera, acrylics

1 The National Art Education Association. *Advisory.* Reston, VA: NAEA, 1999. Print

 c. Sculpture—clay, paper mache, plaster/gauze

 d. Collage—paper, cloth, found objects

 e. Computer Graphics

 f. Printmaking – linoleum, cardboard, monotypes

 g. Others—textile arts, film making, photography, architecture

2. Aesthetics

These may become a criteria for grading, so discuss early on.

 a. Structures and Functions

 b. Elements of art

 c. Principles of Design

3. Subjects and Themes

You will decide on this selection, so keep them varied.

 a. Still-life

 b. Figures and genre

 c. Portraits

 d. Imagination and surrealism

 e. Landscape and cityscape

 f. Animals and nature

 g. Social themes

 h. Cultural motifs

4. Art History and Cultures

This discussion helps students understand how artists approach the same theme differently based on their time in history and the people and ideas that surround them.

5. Criticism and Evaluation
 Discussions are on-going during class about the students'
 techniques used. In-progress and end of lesson critiques
 are encouraged.

6. Interdisciplinary Connections
 Explore the ways an assignment connects with and
 reinforces math, reading, writing, world history, or the
 sciences.

If you use one example of all six of these goals and standards
on every project you teach and carefully vary the choices of
subjects, themes, materials, and processes, you will create one
fabulous curriculum.

Tip 42: Conduct In-Progress Critiques for Long Projects

*C*onduct in-progress critiques if a project takes several days to complete or if you see only a few students understand your goals for the assignment.

I am a big believer of the in-progress critique. Here is a chance for each student to take a breath and reevaluate what he or she is trying to express in their art. Every student will hang (or stand) their incomplete work in the front of the room. Everyone brings their chair up close and gets comfortable. If the pieces are large, I conduct the critique in four or five different groupings. I make sure that there is about three inches of space between each work and that each piece is hanging level. Usually, I call for the works alphabetically, and everyone will have to put up their work.

My students love critiques! Yes, they can be daunting if one is not sure what one is doing, but by the end of an in-progress critique, the students are knocking each other down getting back to their workstations to get on with it. I set the ground rules early. This is an opportunity to discuss what the artist wants to say and whether or not he is achieving his goals. Often, this is the time that someone who is particularly skilled in a technique, can explain to her classmates how she achieves a certain look. *I do not allow students to make fun of another student's work.* If a student seems to be belittling another student's work, a long, piercing stare from me will get his attention. The dialogue ends right there.

I start at one end and move through all the art pieces. I like to start by asking the student how he thinks his work is progressing and if he would like any suggestions. The student might reply that

the drawing looks awkward and he cannot decide why. I will call on the class to offer suggestions and after about three, the artist has some new ways of looking at his drawing.

I may ask the class, "What seems to be the most interesting part of Nick's painting so far?"

One student might say, "I think I like the way he is showing little kids having so much fun in an imaginary place. I would not expect Nick to be interested in this subject. He usually likes super-hero stuff." (The class laughs.)

"I agree", I say, "Nick, what are you trying to express in your acrylic painting?"

"I am trying to show a little boy's view of a playground where there are *no* rules. This is a place where grass, mud, dirt, and water play an important role in his freedom. That is why I have put in the boot house, like 'The Old Lady Who Lived in a Shoe'. I miss getting to play like that." (Agreeing nods from his classmates and his teacher.)

"I love the way you have shaded the brown boot, Nick. I can certainly see how much more interesting it looks because you worked from your own boot," I say. "Who has a suggestion or question for Nick on his painting?" (Bethany raises her hand.)

"Nick, what is that blue thing at the bottom supposed to be?"

"It is a park fountain, but I guess I need to add more water splash so you can understand what it is," Nick explains.

"I'd like you to think carefully about what color you paint that fence. Try to visualize how it will change the focal point of the painting if you chose to paint it white or if you paint it a natural wood tone, or a bright color. I'll give you a second to think about it and then tell me what you think will work better for you," I say. (The other students are thinking about what they would choose if it were their painting.)

Nick responds, "Well, I think it needs to be light because the background is in a mid-tone and white would add more contrast. I think that will help draw the viewer into the picture. Maybe I can turn one of the fence rails into a fork to make it funnier and add a different height down there." (The class heartily agrees.)

I finish up with, "I think you are off to a great start. I like the humor and innocence you are going after. I would add that you consider changing the horizon line, as it is dead center in your painting. Do you have any other questions or problems you would like some feedback? No? Alright then, we'll move on to Stephanie's painting."

As you can imagine, this takes a while! To get through the whole class will take about 80 teaching minutes. I have the opportunity to point out to the whole class when someone has extraordinary talent in a particular area. I get to brag on students who seem to be trying hard and succeeding. I pull out prints of famous paintings if I feel someone has parallel ideas to a well-known artist. I will make suggestions for career choices if someone shows strengths in particular areas. (By the way, the student mentioned above is now an architect and his painting critique is a true story. Nick participated in the prestigious Auburn University Rural Studio Program where thinking about building houses like "The Old Lady in the Shoe" would be perfectly acceptable).

The students expect me to point out strengths in an incomplete work and a possible weakness in the work. Often, just seeing how far behind a student is as she sees her work surrounded by the other works will motivate her to take her work home to do some extra work. Remember, this is not the final critique, but a work-in-progress critique. It encourages the students to talk about their work among themselves, not just with me. It creates trust and prevents isolation among the students. It is indeed one of the most

rewarding parts of being a high school art teacher. Can there be disagreements? You bet! I love the disagreements if each side can back up his or her opinion. My job is to keep discussions from being cruel and mean spirited, yet allow each student to have a different point of view and to learn valuable communication *life skills* in a constructive way.

Tip 43: Hold Scheduled End-of-Project Critiques

O ccasionally, hold an end-of-project critique. Let your students know that you have one planned.

You will not critique every project you teach. You can decide when a critique would best benefit the students. Let your students know on what day the critique is scheduled.

Once again, the students move their chairs to the critique area. Before we begin, I let the students walk in a line to get up close to the displayed pieces. This is helpful before the discussions begin because each student has a chance to see the minute details of the artwork. I have collected some very fine picture frames over the years, including some with elegant linen liners. I like to insert a painting into the frame as it is being critiqued. This helps the students focus on the piece we will discuss. I also have many good quality cream and white mats, in standard sizes, to enhance paper art works during critiques.

When the students get settled in their seats, I randomly ask someone which piece is their favorite work and why? This is an open-ended question. You can expect any kind of answer. I use the *elements and principles of art* as I guide the students as they try to critique the work. I explain that if one can describe art in these terms, one can discuss any art, anywhere, with anyone! It is the international language of art. Therefore, one can attend a New York City cocktail party and take part in any visual art conversation with ease and confidence

Let's say I call on Tervell, who says, "I like Virginia's painting because I like the mixed media she used. I especially like the way

the pink tissue paper creates new colors over the yellow acrylic side of the painting. All those unstable squares create a movement I like. Virginia took as long to complete her work as it took me to do a realistic portrait! Really, there is a depth to her painting that I love to look at."

I ask Virginia, "Tell us how you feel about the finished painting."

"I was trying Formalism, and I was concerned with the arrangement of shapes and colors rather than specific recognizable objects. I used a brayer to layer the colored tissue papers and I absolutely loved the process as much as I love the final painting. I am sure my Dad won't understand it, but I know it goes with me to college next fall because it makes me feel confident!" (Students laugh)

After the individual critiques are over, I ask who has changed their opinion on a particular piece and why. "Who wishes they had done something differently and why?" I will ask who took the bravest leap into new areas unlike their usual style and why? Who thinks this is their very best work and why? Who deserves their work to be out on display in the foyer and why? Who liked the assignment, but not their own work? Who thinks they would do a better job if they had it to do all over again and why? Who wishes they had rearranged their composition, and how would they have changed it?

A good critique is like a good meal one feels and full and satisfied. You would be surprised how many students check out supplies to rework a project, *even after grading, just to satisfy their desires.* Those have been some of the sweetest moments of my career.

Tip 44: Design a Visual Course Syllabus

For each course you teach, design a one page planning form. This sheet has blocks representing each week of the course. Write the date covering each week in the upper right corner of a block. On this sheet write in the projects, you plan to teach during the course.

This is not a lesson plan, but a *visual* course syllabus. On the following pages, I will give you a blank form for an 18-week course, and then I will show you some examples of actual sheets that I have used. I have selected very old course syllabi to share, but you will see there is a timeless nature of a well-balanced program. The ones I have designed are for one-half year courses taught for five days a week and ninety minutes per class.

You will design your own sheet based on how many weeks you teach each of your courses. You will need the school calendar to write in the dates and holidays. The left column represents the first semester and the right column represents the second semester of the course. You will design a one-page sheet for each course that you teach.

Here is how I fill in each block: I only list the medium we will be working in and the theme of the project. If I have room, I will make a note about the location of important information needed to teach the project. Do not write in-depth information because you do not have room for it. This chart helps me visualize where I am in the course, such as if I am teaching sculpture, printmaking, outside nature drawing, painting, etc. I notate in each weekly block events that will affect the week: for example, state testing dates, holidays, and exams. There are usually three-day teaching

weeks that are perfect for teaching certain assignments. For my eighteen-week courses, I actually use a twenty-week planning form. I use the nineteenth and twentieth blocks for bonus projects or as adjustments for unscheduled canceled school days.

By the time the course is over, these sheets are not a thing of beauty! If I am running behind schedule, I delete a project. I often write everything in pencil so I can make adjustments as needed. These sheets are wonderful to use when planning supply orders because you can glance over the projects that you have planned for the course. I use them again when I am planning a new course and I review old planning forms for "tried and true" ideas. I am aware of the season I schedule certain projects such as outside drawing. Some years, I might coordinate a particular week's activities across multiple classes—for instance, wire sculpture in Art 1 with wire jewelry in Art 2—because I can use the same tools and materials for both classes.

When I was teaching, I could not have lived without these course sheets. I learned from the old ones how I miscalculated the time needed to complete a project. I would then write in the adjustments made for the time actually needed after each project is completed. If my classroom had ever caught on fire, I would have run out the door with the folder containing my past and present planning forms and my current grade book.

Example: 20 Week Planning Form

20 Week Planning Form

Course_____ Year/Term_____

1. Week of____	11. Week of____
2. Week of____	12. Week of____
3. Week of____	13. Week of____
4. Week of____	14. Week of____
5. Week of____	15. Week of____
5. Week of____	16. Week of____
7. Week of____	17. Week of____
8. Week of____	18. Week of____
9. Week of____	19. Week of____
10. Week of____	20. Week of____

Example: **Art 1 Course Planning Form**

Fall

2 0 Week Planning Form Subject: *Art I*

Text: *Art Talk*

1 Fees, seating, shelves, monitors, Discipline. Base liner: Draw your hand, face, imaginary person in a chair, line model, verbal desc. of still life	**11** 10-18/ 10-22 Fairlien Cause Day - Ti Fri - report cards sent Oil pastels - P.299 Visual Exper White Chalk on black paper
2 8-16/ 8-20 Blind Contours. Blind Contour of a hand turned into a scene	**12** 10-25/ 10-29 Charcoal Still-life of a cowboy theme
3 9-23/ 8-27 3 Contour drawings of a hand in 3 different mediums. Body drawings based on 7½ heads.	**13** 11-1/11-5 Drawing Circle Composition Colored pencils in an analogous color scheme, 8 overlapping images - sink, emerge float, Spots, merge, social comment A.B. Dot.
4 8-30/ 9-3 Skeleton Developments, front & sides.	**14** 11-8/ 11-12 Thurs +Fri Holo (Veterans Day) Catch-up days.
5 9-6/ 9-10 Blind contours of full body life poses on large paper	**15** 11-15/ 11-19 Relief carving in balsa wood of an insect or crustacean or a new creature based on real p.25 A.R. Teacher. creatures
6 9-13 / 9-17 Dye painting of groups of blind contour figures	**16** 11-22/ 11-26 Thanksgiving 2 Day Week-Mo Color mixing in tempera Paint a color wheel. Use egg cartons.
7 9-20/ 9-24 Nicholas + Alexander test Life drawing in regular contour	**17** 11-29/ 12-3 Value scale b+w on half Day Non-Objective tempera painting with textures
8 9-27/ 10-1 Life Drawings of student models in uniforms	**18** 12-6/ 12-10 complimentary painting of poinsettia's
9 10-4/ 10-8 Exit Exams outside nature drawing Art Talk - p.145 Chapt 6 Shape, Space + Form. Discover Drawing p.96	**19** 12-13/ 12-17 Christmas Card paintings, labels, cards, wrapping paper
10 10-11/ 10-15 (13th 1st qt. ends) Picasso Video Formalism Still-life in Oil pastels T.R.B. p.30 Text p.62 "Pet in Focus" 208-Disc. Drawing	**20** X Jan 7th - Report cards sent

As stated in the Alabama State Course of Study the art curriculum must be flexible. Adjustments to curriculum will be necessary due to individual facilities, materials etc., available to teacher

Example: Advanced Art Course Planning Form

2 0 Week Planning Form

Subject: _Art II & III_

Text: _The Visual Experience - Art II_
Art III _Discovering Drawing_

1 Sketchbook: 20 drawings + 10 hrs. Base line of a model. Hand out art kits + experiment. Design sleeves + portfolios. Written test: Light Logic	**11** 10-18/10-22 Acrylic painting. Add glazes + critique
2 8-16/8-20 Charcoal Drawing of stacked chalk. Videos of light logic. Value chart in graphite	**12** 10-25/10-29 Outside landscape pastels - Back pasture. Discover Drawing - Color - p. 153 Videos landscape drawing + pastel
3 8-23/8-27 Still life Value drawing in graphite	**13** 11-1/11-5 Wire sculpture - Alex Calder 3-D. Art
4 8-30/9-3 Still life valued drawing in graphite	**14** 11-8/11-12 Thurs + Fri off Discover Drawing p. 58 Vet's Day. Holiday Pointalism set up of Natural Fall Produce, trees, dried leaves, ect. in colored pens.
5 9-6/9-10 Still life: value studies + critique	**15** 11-15/11-19 Pointalism continued
6 9-13/9-17 Calligraphy - basic forms	**16** 11-22/11-26 Thanksgiving - 2 Day off: Mon+Tue Gesture Drawing 30 sec. Life drawings. Discover Drawing P. 120
7 9-20/9-24 Nicholas + Alexandria test + field trip. Measurements for alphabets	**17** 11-29/12-3 Disabled Vets poster contest. Commercial Art. Careers in Art. Chapt 14 p. 186
8 9-27/10-1 Calligraphy tags for Honor BD. Full lower case letters. Full capital letters	**18** 12-6/12-10 Block printing of an animal, insect, or crustacian. Chapt 12. p. 143
9 10-4/10-8 (Testing) Collect acrylic painting ideas - 50 18x24 canvas. Draw in vine. Lightly paint whole surface.	**19** 12-13/12-17 3rd Per. Exam: 16th-17th Wed. Architecture appreciation. Frank Lloyd Wright. Draw an outside plan for a home. Sketchbook due - 20 drawings/10 hrs.
10 10-11/10-15 (13th-1st 9t. ends) acrylic painting-based on personal style. Sketchbook due 20 drawings/10 hrs.	**20** ✕ Jan 7th - Report cards sent

As stated in the Alabama State Course of Study the art curriculum must be flexible.
Adjustments to curriculum will be necessary due to individual facilities, materials etc.,
available to teacher

Example: Art 1 Special Theme Course Planning Form

Theme: American Accents

20 Week Planning Form

Course Art I

Year/Term ___ Fall

1. Week of 8/14-16 3 days Draw pre-instruction drawings of: hand, portrait, person in chair + still life. Review: Seating chart, grades, fees, monitor duties, discipline plan + goals for class.	**11.** Week of 10-21/25 5 days Perspective/ Heade Foreground, Middle Ground Sargent + Background. graphite value scale
2. Week of 8/19-23 5 days Pre-instruction self-portrait drawing in a mirror and of an actual still life. Draw blind contour of hand + reg. contour of hand in pen. Review Mary Cassatt	**12.** Week of 10-28/11-1 5 days Oil pastels + water Sheeler Precisionism still-life Demuth Ault
3. Week of 8/26-30 5 days Betty Edwards style of drawing on glass. Pt 2 on video. p.136 in Discover Drawing	**13.** Week of 11/4-8 5 days Folk Art Pippin Animal reprousse' in foil
4. Week of 9/3-6 McClosky 4 days Harnett Contour Drawing of fruit cut Pape in progression	**14.** Week of 11/12-15 4 days 3 overlapping Douglas story scenes in Birchfield pastels Marsh Mon - Vets day Grosz
5. Week of 9/16-20 Hicks 5 days Calligraphy Freake-Gibbs Copley Peale Wright	**15.** Week of 11/18-22 5 days continue pastel scene
6. Week of 9/23-27 4½ days "The Peaceable Kingdom" Hicks style in markers and calligraphy Great exams - Fair ½ day Wed.	**16.** Week of 11/25 + 26 2 days Intro to Tempera paints Mix 12 colors in egg carton Thanksgiving holidays
7. Week of 9/30-10/4 5 days Torn paper landscapes Bingham Cole Bierstadt	**17.** Week of 12/2-6 5 days Mix gray values scale Bradford of tempera Brown Paint a warm or cool Gifford landscape or still-life
8. Week of 10/7-10/11 5 days Life Drawing Eakins Johnson	**18.** Week of 12/9-13 5 days O'Keeffe Tempera Flowers enlargement painting of live poinsettias
9. Week of 10/14-10/18 4½ days Collage of a social Marsh issue Pito Harnett Exams Mon + Tues. ½ day Tues.	**19.** Week of 12/16-20 4½ days Finish painting + Clean out supplies Exams Thurs + Fri
10. Week of ___	**20.** Week of ___ Extra time: Self portraits in a mirror

165

Example: Advanced Art Special Theme Course Planning Form

Theme: *American Accents* **20 Week Planning Form** *Fall*

Course _Art II_ Year/Term _____

1. Week of _8/14 – 16_ 3 days *(illegible handwritten notes)*			**11.** Week of _10/21 – 25_ 5 days *recisionist (illegible)*	
2. Week of _8/19 – 23_ 5 days *(illegible) Raicin sketchbook ideas*			**12.** Week of _10/28 – 11/1_ 5 days *(illegible)*	
3. Week of _8/26 – 30_ 5 days *(illegible)*			**13.** Week of _11/4 – 8_ 5 days *Disabled Veterans poster contest (illegible)*	
4. Week of _9/3 – 6_ 4 days *(illegible)*			**14.** Week of _11/12 – 15_ 4 days *(illegible) Mon. Veterans day*	
5. Week of _9/16 – 20_ 5 days *(illegible)*			**15.** Week of _11/18 – 22_ 5 days *Graphite (illegible) a still life (illegible)*	
6. Week of _9/23 – 27_ 4½ days *(illegible)*			**16.** Week of _11/25 + 26_ 2 days *(illegible) Thanksgiving holidays*	
7. Week of _9/30 – 10/4_ 5 days *(illegible)*			**17.** Week of _12/2 – 6_ 5 days *(illegible)*	
8. Week of _10/7 – 10/11_ 5 days *(illegible)*			**18.** Week of _12/9 – 13_ 5 days *Bingham (illegible)*	
9. Week of _10/14 – 18_ 4½ days *(illegible)*			**19.** Week of _12/16 – 20_ 4½ days *(illegible) Exams Thurs + Fri*	
10. Week of _____ *(illegible)*			**20.** Week of _____ *(illegible)*	

166

Tip 45: Use Art History to Reinforce Every Project

U se art history and cultural works of art to back up every project that you teach. Use computers, available prints, textbooks, library books, magazines, DVDs, and other visual media to connect the project with history and culture. Make this a leisurely and interesting use of class time.

As a teacher, I never believed I was trying to create a little creature with "good" artistic skills. I passionately believed that I was trying to create a thoughtful, caring, curious, and interesting citizen of the world.

Art history and the exposure to cultural works of art add interest and importance to the project you are introducing. If you make art history fascinating and lively, your students will learn to love it too. Spend time asking the class to locate details in the historical art piece you are showing. Give them time to take in and appreciate all there is to see. Offer opportunities for students to disagree with each other on how they feel about an art piece. Connect old work with ideas that are similar or unlike today. Tell interesting trivia about the artist or the subject. Describe, with interesting details, how the beliefs of certain cultures may differ from beliefs held by many in the class. Connect the time the art was created to what was historically important at that time. Use proper art terms as you ask the class questions. Ask students to find the focal point in a painting and explain why that area is the focal point; to point out soft and hard edges to shapes; to point out low intensity color and how that affects the center of interest. Ask questions such as: Do you believe the artist is trying to get

the viewer to see the subject in a particular way? Do specific objects in the art have a particular meaning for the period when that art was created? Did the culture that the artist lived in affect the attitude of the artist? Compare two artists working in similar mediums, yet created different meanings in their works. All of these questions about art created by others will help the students settle down and really look at the art.

When you introduce the project relating in some way to the historical or cultural pieces you just showed, your students will have a new respect and interest in what they are about to do. When you show various approaches to a theme that are all successful, you encourage your students to be confident in pursuing their own ideas. The wheels begin to turn in their heads and creativity begins to do its magic.

I do not give very many *fact* related art history tests. I prefer giving discussion questions. I want my students involved in learning to love and question art, not to live in fear of tests. I am most happy when during a critique of a student's work, another student makes a comparison to a particular artist we studied. When the rest of the class casually nods in agreement to the point made, I glow, inside and outside.

Tip 46: Require a Sketchbook from Your Advanced Art Students

*R*equire a sketchbook from your Advanced Art students. Grade it once each grading period and count it as an exam.

I required students to keep twenty drawings (for a total of 10 hours of effort) in their sketchbooks for each nine-week grading period. If I estimated that the student spent 10 hours of work doing the 20 drawings, I will give the student a 100 on the exam grade. It took me several years to come to this ratio, but it is a very good one. Through trial and error over several years, the sketchbook requirements settled to this system. It allows every student to raise their grade substantially, or it can lower the term grade for those students who only show up for class. Neither parents, nor students, nor administrators complained about the sketchbook grading system.

This is the way I write a perfect grade on the back of their sketchbook:

20 drawings/10hours of effort = 100!

For grading, I go through the pages first and count them. Now, I do not want, nor do I expect, all of these drawings to be "good". A sketchbook should be like a personal diary; perfection is not the goal, exploration is the goal. I want to encourage out-of-the-ordinary ideas. I liked to keep a convenient file box with sketch ideas to stimulate the students. This is very important because students need many fresh ideas to encourage them to develop their own interests. The volume of sketches is important because the students need to push past what they normally draw.

They will have to dig deeper to get twenty. I put a tiny ink check mark on each drawing so the student will not try to recycle it next term by tearing it out and gluing it back on a new page, a trick I've had students try in the past. (They will claim they drew it somewhere away from their sketchbook and therefore they had to attach it into the sketchbook later. The kids are clever when they are desperate!)

Many students are scared to death of keeping a sketchbook. That is why I give so much praise to those brave souls who take risks and try out new ideas. One does not have to draw accurate proportions to have a fascinating sketchbook.

After I count the pages, I go back and estimate actual hours spent on the drawings. Of course, this is tricky, and it is an estimate. I write tiny hour and minute numbers at the bottom of each page and then I total them at the end. I hope to see gesture sketches that took minutes, along with more involved drawings. Every semester, I have students making 100s and students making 0s. Here is an example of a grade issued to a student who did not produce as required and how I came to the grade:

Divide the number of hours estimated that the student put into their sketchbook by the number of hours the student was supposed to put in (10 hours). Next, divide the number of drawings the student did by the number the student was supposed to have (20 drawings). Finally, average the two together.

For example, say someone put in 6.5 hours into his or her sketchbook. Divide 6.5 by 10 (you will get .65). Now, let us say the same student drew 16 of the 20 drawings required. Divide 16 by 20 (you will get .80). Now for the average, add the two together, .65+.80=145, divide by 2, and you will get the sketchbook grade of 72.5 or rounded to 73.

On the back of the student's sketchbook write:

16/20 required drawings and 6.5/10 hours of effort = 73

When I discuss the sketchbook grade, I want the student at my desk so I can ask questions about what the student's interests and motives were. This is precious time. This is an opportunity for me to hear about the student's life, his dreams, his fears, his loves, his pressures. There is full focus on this one child. They will usually sing like a bird as they get a chance to explain their sketchbook to me. I listen very carefully and I ask questions. This is not *my* time; it is *their* time. Because the students will *expect me* to call them up for these discussions, they seldom show up with empty sketchbooks. Even if the student is going to receive a perfect score on the sketchbook, the student must come to my desk for the one-on-one discussion. Little is more frightening than a one-on-one quiet discussion with a teacher they like when they have not done their work.

After I show how I counted their hours of effort and the number of drawings, and after we have our discussion, I critique and write ideas below their grade for their next term sketchbook. This is important to the student and me. When the student turns in his sketchbook next time, the first thing I do is review what I wrote the last time. Here is what I wrote for Jimmy:

20/20 required drawings 5/10 hours of effort = 75

Jimmy, I believe I see many last minute drawings here that don't show much thought, such as your name in block letters. Let me see more outside nature drawings next time. Try drawing inside your barn and the area where you feed your horse. Share with me more of what it is like on the farm. Find a quiet place to draw where you will not get distracted. I loved the drawing of "Jake" the coon dog;

you showed interesting facial expressions and I would like
to see more of what goes on in his life too!

Jimmy may not be too happy with the 75 on his sketchbook,
but at least he has some *specific* places he can start next time and
this appeases some of his frustration. Because these notes are
there for the world to see, I am aware that Jimmy's parents may
read what I wrote. (I hope that they do). His parents will see what
was expected and what he submitted. His parents will see that I
have concern for Jimmy and I am trying to help him do better.
It would be hard for Jimmy to tell his parent, "She doesn't like
me so that is why I got a 75 on my sketchbook." Think ahead,
young teachers.

Because I required keeping a sketchbook in Advanced Art,
many students decided not to take those classes. This meant that
I always had a class of excited students anxious to explore art,
and a creative bunch of students, not just those trying to meet
graduation requirements.

Tip 47: Set Appropriate Weights for Sketchbook Grades

The sketchbook grade you give should make up 20% of the grading period's total grade.

At the school where I last worked, we used a half-year grading system. That is, students took four courses in the fall through the December holidays, and then four different courses from January through spring. This allows students to take eight courses per year. Each class is 90 minutes and meets five day per week. Report cards go out two times per course.

I realize some schools have 45-minute classes for the entire year. Some schools require that report cards go out four, six or eight times. Different lengths of class times, as well as frequency of report cards issued, will influence your sketchbook requirements. You may choose to decrease or increase your required drawings and hours of effort per grading period.

Once you have made these decisions and you have discussed with each class how you will grade sketchbooks, you will need to explain how the sketchbook grade is averaged with their other art grades. *Discuss this fully at the beginning of each term.* I write three different scenarios on the board to demonstrate how important their sketchbook grade is.

Scenario 1
If the sketchbook counts as an exam and an exam counts 20% of their nine-week grade, let them see how their grade is affected if they decide not to do a sketchbook:

If my first imaginary student had a 97 average and then made a zero on the sketchbook, this is how it is averaged: 97+ 97 +97+97+0=388 divided by 5=77.6. The classroom grade counts as 4/5th of their grade and the sketchbook is 1/5th of their grade.

In other words, the student will now get a C in art for the grading period instead of the A he was expecting because the student made a zero on his sketchbook!

Scenario 2
In my second example, the student has a 97 classroom average and a 78 on her sketchbook. Write out the averaging procedure for the students to watch:

97+97+97+97+78=466. 466 divided by 5 is 93.2. Therefore, she will receive a 93 on her report card.

Scenario 3
In my third example, the student has a 97 average and makes a 100 on the sketchbook. Ask the class to figure out what that student will get on his report card. Give them a moment to figure it out and then ask for an answer.

Here it is: 97+97+97+97+100=488. 488 divided by 5 is 97.6. Therefore, the student will receive a 98 on the report card.

You might think this is excessive explaining but it is not. These scenarios give your students an opportunity to see how important their sketchbooks are.

Create three different sketchbook grades based on hours of effort and drawings done. Write an imaginary comment on each one based on the grades given. See the previous page and below for examples of some of my own comments to past students:

20/20 required drawings + 10/10 hours of effort = 100!

Cassandra, the architectural studies are fascinating! I adore the way you incorporated Frank Lloyd Wright's principles into the design of three houses in our area. The use of pinewood and the vertical lines is clever. The gentle lines of the Eero Saarinen inspired furniture for the deck is wonderful. I believe you have the interest to carry furniture design even farther. Next time, look up the home and office furniture designed by the couple Charles and Ray Eames. Consider working in watercolor instead of markers. I am very impressed! What could you do with some of our native plants in the yards and outside planters of your house?

Tip 48: Provide Check-Out Boxes for Make-Up Assignments

K*eep an area for check-out boxes in the art room. In two of these small boxes, keep worn down pencils and erasers for students to use to complete make-up work.*

Count on this. Students will be absent every day. Prepare for how these students can immediately make up missed work. You do not want the student to be one-step behind throughout the whole project.

The better art students *always* want to work on their projects beyond the allotted classroom time. Their desire to create their art as they envision it will often drive them to work on the project longer.

You need art supplies available for both of these groups of students. You do not want them taking art supplies out of the supply boxes provided on the tables. If just *one* student forgot to bring back the supplies, all the other students who sit at that table, throughout the day, will not have supplies to work with.

I keep check-out supplies in old, worn out table supply boxes. Of course, I label the top of each one. At the end of the term, when I refill the table supply boxes, I replace the worn, short stubby pencils and put them in one check-out box, and I replace the worn erasers and put them into another check-out box. Other check-out boxes could hold charcoal supplies, pastel supplies or whatever you were using. I request that each student tell me when he checks out these supplies and when he returns them. I am not preoccupied with keeping track of these check-out supplies. I am happy that all students have access to quality materials to work with at home, even if the materials are not "pretty" any more.

Chapter 5: Personal Tips

Tip 49: Ask for Anonymous Critiques of Your Teaching Style and Completed Projects

*A*t the end of every course, let the students anonymously critique the projects they did as well as your teaching style. Ask for advice on what would make the class more effective.

Yes, I realize this is as much fun as jumping off a cliff into water of an unknown depth. *Do it anyway.* Prepare a list of questions. Do not shy away from any questions that you *know* you need to ask. Do not allow any talking among the students as they answer the questions. You will need to write these as open-ended questions. Here are a few of my favorites:

1. What project did you enjoy the most and why?
2. What project do you think expanded your appreciation for art the most and why?
3. What project did you dislike while doing it, but now you are glad that you did it?
4. What advice would you offer to help with my future classes?
5. What project did you feel was a waste of your time? Why?
6. How would you explain to a friend what art class is all about?
7. Why would you recommend taking or not taking this art class?

It is enormously helpful to list in advance, on the board, every major graded assignment from your grade book. That way the students will have something to jog their memory as they write their critiques. It is rewarding to recollect how much we did during the course.

Assign a monitor to collect these critiques, so you will not see the authors.

Here is the good news! *No one will read these critiques but you.* Believe me you do not want to be the last one on campus to know how your students feel about your teaching style or what you choose to teach. Allow yourself plenty of time to read these critiques in private. Some students will surprise you with unexpected ways that you were a positive influence on them. Some students will tell you things that you do not want to hear, but once again, *you need to be brave!* When you get to the end of all the critiques, you will see a trend. If the same complaints keep coming up, it is time to rethink how you are doing things. You will find at least one project that you should not teach again. If several students mention something similar about your teaching style that is not working, you can easily make changes next term. Please try not to justify everything you did. We all can improve. I kept some of my critiques for years.

Thought Provoking Questions **about Creating a Teacher Critique**

Are there any areas of your teaching style for which you could use some honest student feedback? If the students can answer anonymously, you will get more sincere answers. Add two more of your own open-ended questions.

1.

2.

I supervised many student art teacher interns from state universities. Two weeks before they finish their high school experience, I would hand them a list of candid questions that I would be asking her/his students to answer. (Sweat would mysteriously appear on their forehead.) I would not read the surveys unless my teacher intern wanted me to. Sometimes the responses were so sweet that the intern could not wait to share them! Here are four questions that I ask (I would typically use the intern's name, for example, *Ms. Brown*, to make this form more specific):

1. What do you hope your teaching intern will continue to do in his/her own classes? What are his/her strengths?

2. As a student, what do you suggest your teaching intern be aware of in his/her first year of teaching?

3. What areas of your teaching intern's personal teaching style do you feel need improvement? Give a specific example.

4. Write a few personal words of encouragement or your parting good-byes to your teaching intern. You are not required to sign your name on this evaluation unless you want to, nor will I read your answers, unless your teaching intern asks me to read them.

Tip 50: Dress Appropriately According to Your Age

D*ress appropriately, neatly, and stylishly, according to your age.*

You may argue that this is a silly and superficial issue for an art teacher. This much I know: For over twenty years, I have often had students thank me for looking "nice," "cool," or "hip," when we took field trips or went to competitions. I believe students like to be a part of a group whose leader is stylish and professional. While coming home on a bus, I have been amused to overhear students spend inordinate amounts of time dissecting the appearance of art teachers from other schools. Men: Check your tie before that next field trip, and get a fresh haircut. Ladies: Does you skirt hang properly? Do you have a full-length mirror that you look in before you leave the house? I am not talking about expensive clothes here, just nicely designed clothes that fit properly. Here are a few other things to keep in mind:

1. **Keep your teeth healthy and brushed.** Do you think that your students do not have fine-tuned observation skills? Well, just listen to how they describe teachers when they do not think we can hear them. Bad breath seems to be at the top of the list when it comes to teacher grooming.

2. **Be careful to not dress seductively.** Students will notice this quickly and will giggle over it to anyone who will listen. The faculty and administration will instantly notice

seductive clothing. *They will not be giggling about it though.* They will see you as immature, insecure, and out of touch with your job. You will find yourself isolated by the other teachers who do not want to be associated with your bad judgment. Women should be careful about short skirts, thin blouses, plunging necklines, and tight fits. Please, do not think what the popular television shows display as acceptable teacher clothing will work at your school! The teacher characters wear these clothing styles to grab the viewers' attention and up their viewer ratings. Do not come to school looking too casual or sloppy. Men, this all goes for you too. Save your sexy/dress-up outfits for those nights out with your friends. You know *those people who are not involved with your job evaluations.*

3. **Allow enough time to prepare yourself for school in the morning.** If you are a night person (as I am), watch the weather forecast in the evening and prepare tomorrow's wardrobe. I iron at night, choose my shoes, and even lay out my jewelry. In the morning, I shower and wash my hair and style it. I eat a leisurely breakfast; I brush my teeth, and put on light make-up. I am not very sharp this early in the morning, so I am grateful to see what the "elf" laid out for me to wear the night before. You will feel so much more confident walking into school, *on time,* looking polished and pulled together.

Now, do not get me wrong. I have not always followed my best-laid plans. There are infamous stories about me over the years. Once, in a frantic rush to beat the clock, I came to school in one blue flat shoe and one short stacked-heeled black shoe! Several times, I have had to

skip washing my hair and people sincerely asked me about having wet hair (it was oily). I have come to school without make-up and several people asked me how long I had been ill. I have rushed into school and flown into the restroom before homeroom, only to drop one-half of my jumpsuit into the toilet. *Frantic* is not the way to start your day. That aura will hang on you like a wet cloud! (No pun intended.)

Tip 51: Speak at a Comfortable Volume

W hen in doubt, speak in a voice one notch lower than your normal speaking voice.

When I began teaching years ago, I would come home voiceless. A speech teacher said that I probably was projecting my voice *higher* and not louder. I tried lowering my pitch the next day and I was stunned at the difference it made! I am sure the students must have felt relief too, not having to listen to my screaming, bird-screeching, strained voice.

Tip 52: Take Advantage of Professional Development

Take advantage of monies allotted to your school for professional development. If you attend only one big event each year, go to your state Art Education Association Convention.

Art teacher conventions are wonderful places for you to choose workshops to attend. You can expect to take four to eight workshops or lectures. I always chose some that were exciting and fresh as well as some that addressed areas where I was weak. You will get to hear interesting and relevant speakers. You'll have the chance to visit rows of tables loaded with new art products, and you have an opportunity to try them before you risk ordering something that will not work in your classes. You can ask all the questions you want, and usually you get a free sample to take home. Conferences also give you a chance to make new friends and have time to share your teaching problems with teachers who *really* understand your stories. You learn and have a good time, too.

Most school systems require *all* teachers to work towards improving their teaching skills by attending approved workshops, taking upper level college courses, or attending seminars. Most states keep accurate records of the actual hours you spend in these endeavors. It is up to *you* to keep accurate documentation of your professional development hours. Your supervisor will ask you to submit these hours regularly and she will endorse or reject your claims. You will hear a lot of talk among your faculty about attending and needing professional development. Do not wait until the last minute to take professional development courses.

Do not find yourself signing up for what you have no interest in because they are available right now. Many seminars are one-hour classes that may take you two hours in travel time. You can nickel and dime yourself to death doing it this way.

Art teacher conventions, on the other hand, are a great way to get most of your hours at one time. These education courses for art teachers are rare. You will need to prepare in advance before attending these, though. You need to pay dues locally and nationally before you can attend. These dues can be expensive. My school always agreed to pay my dues for me. I would always discuss with my principal before asking the school to pay these dues, that way, I could explain that a convention is the most cost effective opportunity to get the training I needed. You may also need a substitute teacher for a Friday to accommodate your travel time to the conference. Ask the principal to pay for this substitute. You will need to make overnight reservations at the convention site; your school system should pay for this too, if you are lucky. Ask for travel and food money. The conference registration fees will not be cheap; ask for money to cover that too.

I can hear you laughing, but every school system has money available for professional development. If you do not ask for it, someone else will. Besides, you have a valid reason to go, because opportunities for art teachers are not as common as they are for math, English and history. Get your course information and budget together before you go speak with the principal. You may have to pay for everything yourself and then submit your receipts when you return. Keep your documentation that proves you completed the event and be prepared to present your itinerary.

Tip 53: Join Your Local Art Education Association

J oin your local Art Education Association and go to their meetings.

Now that you are employed, find out from other art teachers who the contact person is for the local Art Education Association. Go to these meetings and meet the art teachers in your area. You can ask for a print out of the phone numbers and e-mails of all members. It is too easy to withdraw from contact with other art teachers if you feel you are having trouble as a new teacher. *Force yourself to join and then attend these meetings.* At these meetings, others will be sharing projects recently done and will have examples to share with the group. The dues are inexpensive, if any are required.

This is the organization where you will find out about the local and state competitions, and shows for your students. You will be the first to hear who is resigning, moving, or who is retiring from their teaching position. The organization will expect you to contribute in some way in helping them. Your local group is only as strong as each member's willingness to participate. Here you will meet teachers whom you enjoy being with. You might go with them to the state or National Art Education Association conventions. Speaking of the National Art Education Association, (which you must join if you plan to attend your state convention), a very thought provoking journal comes with your membership. This journal has essays, ideas, high quality reproductions of famous works of art, and lesson plans for teaching from the reproductions. If you are able to, try to attend the National Art

Education Association convention. Try to find another art teacher to share the room costs for the hotel. This is the ultimate event for you to learn more about your profession and see how others teach art in other parts of the country, as well as seeing what the new trends are in art education.

Joining these organizations gives one a sense of belonging in one's profession. I have witnessed art teachers who have floundered in their little corner of the school, scared to ask for help and hoping no one notices their ineffectiveness in the classroom. Administrators and other teachers do notice ineffectiveness, even though they may not bring it to your attention. In these instances, you won't find out it is noticed until suddenly, one day, you are fired. Don't let it get to this! Reach out to the art educator community around you.

Tip 54: Subscribe to High Quality Art Teacher Magazines

O rder a subscription to a quality art teacher magazine, such as School Arts, Arts and Activities, or Scholastic Art, even if your budget is very limited. Learn to live within your budget and plan for better funding later on.

I often have not had access to full sets of age-appropriate art textbooks. In fact, I collected almost *all* of my lesson ideas from *School Arts* magazine for the first 10 years of my career. This is a wonderful user-friendly publication with lots of students' examples. The topics are current and the color photos are crisp and helpful. Keep all of your old issues for ideas for future project. I am proud to say that I have had a few of my own projects published in *School Arts*.

You may not have access to expensive art texts. Your best secret weapon is the reputation you build for your program. You will show the community that your students' art experiences are valuable education. You will earn respect and get support for your program in a few years as parents and former students sing your praises. As respect for your program grows and pride in the work your students produce becomes commonplace, the next thing you know, the principal is funding your program the way it should be funded. You see, when you make the *school* look good, you make the *principal* look good. Until that time, you may have to approach your program with the frugality of a monk. This can be especially true if the teacher before you was not creative with funding.

Here is another story. I once taught middle school art in an old industrial arts tomb of a room. There were no windows in

it. All of the old greasy tools (extremely heavy) remained in the closets. The only way I could get any natural light was to open the double garage door connecting us to the Maintenance Shed. This is where the crew worked on the lawn tractors, welded and repaired. It was loud. I kept this door open to get some light into this dimly lit art room. We regularly fought off bees, the heat and fumes. Of course, I did not have textbooks, so I taught from my *School Arts* issues and showed examples of important art found in my personal collection of art books, along with the few art books that were available in the library.

We still had a vibrant art program. I made sure that we had weekly campus art displays and a formal end-of-the-year student art show. I just chose to develop the program using the small art fees collected from each student. My eyes were on the prize though. I knew that eventually I would get more money for the program once I had earned respect. Groveling was not necessary because the "money people" want to fund productive programs that are stimulating the students. Build up a good reputation for your program so you will have many people who are happy to support you and plead your case before the school board.

Tip 55: Improve Your Own Skills as an Artist

T*he better artist you become, the better teacher you will be.*

I know that I started teaching art with poor artistic skills. I did not completely understand the nuances of the color wheel. I had not been exposed to the formal principles of light logic nor did I have a clue how this lack of knowledge affected my drawings. My college professors did not expose me to scientific diagrams showing body and facial proportions and ratios. Because I was studying and majoring in art education, I missed much of the art training that I needed. Education courses take the place of many studio art courses. I am sure my story is not unique.

In my early years, I was very good at intuitive, abstract, and non-objective paintings in acrylic. (I still work in and teach these styles). I was taking art courses in the early 1970's and these styles were *the* styles to be working in. Professors smirked at Realism for showing a lack of original thought. Therefore, I did not have enough training in the laws of drawing and painting that were so valuable to artists over the centuries.

Regardless of what your strength is as an artist, it is not enough to teach only in the areas that you are good. You need to teach a well-balanced program, offering explorations in styles of art that you may not enjoy.

My advice to you is to seek out workshops, courses, and seminars that can help you work on your weaker skills. Your undergraduate art education degree, if completed in four years, does not offer you enough opportunities to develop the artistic skills you need to teach general art courses.

Thought Provoking Questions **about what Art Skills You Need to Improve**

Think about your art studio experiences in college. Where are the gaping holes in your training? Sometimes, one just needs to refresh one's skills with a different instructor.

Below, list two areas of art where you will improve your skills, whenever the opportunities arise.

Tip 56: Expose Yourself to Other Cultures through Travel

T*ravel will make you a more interesting teacher.*

I think one of the reasons why I got one of my first teaching positions was the list of "Travel Experiences" on my resume. I was able to discuss with enthusiasm in my interview my discoveries of art. This principal told me he believed that "Good teachers can teach anything because they are interesting people."

Travel forces us to be more accepting of cultures unfamiliar to us. It shakes us up and brings us back to the thrill of discovery, no matter what our age. When I teach art history and I describe particular artworks and architecture that I have seen, I know excitement shows on my face. I can feel the joy of discovery all over again!

It is a good habit to keep a diary of your travels, as well as taking good photographs and keeping a sketchbook. The trips I remember *best of all* are the ones where I kept a sketchbook. The memory of bright bougainvillea flowers and the aqueducts south of Mexico City are with me forever. The smell of the dusty bus before the rain in rural Mexico, along with the vision of natives carrying caged chickens on that same bus is with me forever. The bright colors painted on the houses in Mexico are very different from the scenes and the words written on Bavarian homes. I believe that regardless of what our future will be, a life filled with the memories of experiences and travel can never be taken away.

Use your discoveries in the classroom. I can describe the unbelievably steep steps up the Mexican pyramids. (I use a chair to step on to show *how* steep I mean). Have pictures taken of you

against important works of art. Use these photographs in class to support your exciting experiences and adventures.

I can describe the brilliant blue that falls on the floor inside Chartes Cathedral, even though the windows are very high up. The thick, cobalt blue stained glass in French Cathedrals creates color saturation that is impossible to achieve with the painted or thin stained blue glass of today.

I can describe the size of the foot of "The David" by Michelangelo in Florence. I can describe the rising waters in St. Mark's Cathedral in Venice. I can describe how the inside of the Sistine Chapel looked before Sony paid to clean it. I love to tell a story about the famous painting on the backside of wall behind the Resurrection painting. (It is by Raphael).

I can teach about the famous "Christina's World" by Andrew Wyeth and show the students the size of the painting by a picture of me standing next to it. I can show the class a picture of me and "The Persistence of Memory" by Salvador Dali and watch their surprise at just how small it is. I can describe the frescos and body castings in Pompeii, and how the Mona Lisa really looks. I can describe the stark architecture in Munich, Germany and the golden mask of King Tut.

Where is *your* dream location to visit? Begin saving now for your trips.

Tip 57: Plan and Chaperone Tours Abroad

I f you plan an art tour abroad for your students, be sure to take another certified teacher as a chaperone.

How wonderful of you to share your delight in travel and exploration with your students. You can have a profound influence on young lives as they learn to view the fascinating world we live in. *Carefully select the parents who travel with you.* Parents may not have the same goals that you have for the trip. Parents may not have not been exposed to the teaching techniques that you have. Parents might allow, and participate in, inappropriate activities with, or within sight of the students. I have had parents phone *all* of the other parents back home in the U.S. to complain that the teenagers were not getting enough beef in their diet in Paris, France. I have seen married couples get into ugly heated arguments in front of the students.

If you are organizing a tour, by all means, include parents who want to join you. Of course, they can be entertaining and add support. But I also recommend that you take another teacher from your school to go with you. This teacher can be included in any disciplinary or medical decisions that you may need to make. This teacher should not have a child on the tour that could influence his or her decisions. This teacher will be included in the meetings with your principal when you return. This teacher will be your confidant when hard decisions need to be made, such as airline problems. I do not want to discourage you from touring with your students, just be wise about your chaperones.

Tip 58: Guide Overwhelmed Students by Actively Sharing Your Thoughts

T *he prime predictor of a poor quality art program is how much time a teacher sits behind their desk.*

Young teachers, naively, will believe that once they explain and demonstrate the project, the teacher can now sit down and do paper work. All right, an important aspect of education is for students to learn how to solve problems on their own, and yes, I encourage this every day, too. Of course, students learn from "the struggle," and the rewards are phenomenal. My students create some of the most amazing works at home, where nothing interrupts their work.

A goal for your students is for them to be able to create works of art, as they perceive it, without any input from anyone else. Getting to this point can be a completely different story. Sure, you can sit down after you explain what you want from the class, and yes, maybe ten students will fly and create wonderful, personal, and unique works of art. In fact, with my Art 3 classes, I had reached a point with those advanced students where I could actually say, "Now, dazzle me!" The other classes you teach will need more from you.

Try to remember that most of your students do not come from the kinds of creative environments that produced you, an interesting and eloquent art teacher!

In the past, I have asked my students to discuss their exposure to art, art books, creating art, art that hangs in their homes, or artists they know. I was naïve about what their art experiences had

been. There are high school students who do not have magazines or *any* kind of books in their house, mobile home, or apartment. They have never looked at a beautiful art history book before. On the walls of their homes hang school photos only. Extra money is spent on better shoes, not art supplies. No one makes a living in their family by doing artistic things. Many have never been more than 60 miles away from their hometown and have not visited an art exhibit. They have never heard adults speak about what kind of art they like or do not like. In other words, they come from environments where visually interesting imagery is not valued, or not understood by the adults.

David Sutherland produced an exceptionally riveting program for PBS called *Country Boys*. This documentary is about poor teens, growing up in the Appalachian Mountains with the harsh realities of life. He showed a family consumed with what tricks it took to keep their son getting his Social Security Insurance check each month from the government. They were not concerned about the boy's education one bit.

This brings me back to your role in teen lives. Your students need to *hear* your thoughts and values about art.

Most of your students will get a good start after seeing a well-done demonstration, but many will hit a creative wall quickly. These students have little experience with creating things. It is not unlike putting children in an Algebra II class before they have taken and passed Algebra I. When they quit working, it is not because they are lazy or trying to annoy you, but because you have not asked the right questions to keep them moving

Let us talk about Lelia, a talented Art 1 student, as an example:

Lelia is sitting, pouting with her arms folded. She is not looking at her sculpture in front of her. I say, "Lelia, turn your

sculpture around slowly for us to look at all four sides. Do all of the sides seem to flow together?"

"No" she answers.

"Well then, which of the four sides do you like the best?"

"I kind of like this side, I guess" she whispers.

"Why do you like that one side?"

"Because I carved lots of little squares around that deep cut line," she ventures.

"I like that side too. How could you repeat some of those square groupings on the next side, and how could you allow the deep cut line to flow to the next side?"

Lelia sits up straight and says excitedly, "Oh, I know what I want to do!"

"Good!" I respond. "Now, what area of your sculpture are you most unhappy with?"

"I don't like that big, flat, boring rectangle there," she says.

"O.K., then can you carve into the flat surface something else you have designed?"

"I could carve some shallow flowing lines into it," she says.

"I think that is an excellent idea, Lelia. That will create unity in your design." I continue, "By repeating these patterns, you are leading my eye around your sculpture, but because you have different depths of cuts, you are adding variety and visual interest."

Lelia is very anxious for me to move on. She is busy now and she does not want to be disturbed. She has entered "the zone," that wonderful place where creativity flows in a mysterious way. She quickly folds up the note she was about to write to her friend and stuffs it into her pocket.

In the above example, I just stopped a potential discipline problem. Lelia was frustrated and she was sidetracked from her project. She could have said, "This project is boring and stupid and when will we do something else?" Let me assure you, this is a common response from students who don't know what to do next. It is not that it is boring; it is just *overwhelming.* They do not want anyone to see them do something dull or childish. The students need a little help developing their ideas. You have to teach them how to do that.

Frequently my principals observe that, "Mrs. Johnt actively walks around the room and engages the students one on one."

This is not only a joy of teaching, but also a requirement.

Once you get into this mode, you will not miss sitting behind that big desk.

Thought Provoking Questions on Your Early Exposure to Art

Because you have consciously chosen to be an art teacher, you obviously have had rich exposures that have influenced your creative thinking. Describe the places, people, and experiences that affected your creative spirit. After you have completed your recollection, discuss if you believe you were exposed to more creative thinking and creative people than the majority of your elementary school classmates. If yes, then in what way? The purpose of this exercise is to help you see that not all students start an art class equally. You will need to develop artistic thinking on all levels of exposure.

Tip 59: Handle Inappropriate Behavior Quickly and Calmly

D*o not pretend that you do not hear inappropriate comments, and do not play dumb to innuendos made by your students.*

If you are a new teacher at a middle or high school, I predict that you will have five classes before students give you "The Test." The Test is necessary for students to establish where your limits are. They want a clear understanding of how far they can go with you. Everyone, meek, mild, or mean will watch how you respond to The Test!

Now, I am a woman, so this example will be from the female perspective. Men, you will undoubtedly deal with your own version of The Test, so be prepared for it—I address your side of things at the end of this Tip. Here is how The Test works for women. A male student you have just walked away from will say, loudly enough for at least five people to hear, something like this, "I bet she's a hell of a good kisser with those big fat lips; I bet she is good at *other* stuff too." You'll hear giggles from the boys and the girls around him and everyone will glance up to see your reaction.

I certainly hope that you have covered your rules and procedures with every class by now! Have you posted your classroom rules and the consequences for breaking those rules on the wall? Did you explain to them how you would handle inappropriate comments in class?

I would quietly, yet firmly, look the young man in the eye and call him out into the hall for a conference. I repeat *exactly* what I heard him say. I tell him that it was an inappropriate comment,

and he knows it too. Do not be surprised if he denies that the comment was aimed at you, but instead it was about a girl he knows. Don't let the conversation go down that path. It would be easy to let the whole thing go because you *want* to believe he did not aim the comment towards you. You really do not want to get involved with this because discipline is a lot of work. I know. I've been there. But I would nonetheless see this through. I would push on and say to him, "It does not matter to me *who* your comment was about. It was an unacceptable comment to make in class." This is his one *verbal warning*. I would go on to explain that if it happens again, I will issue punishment work and that I will send the discipline principal a copy of what I heard on *both* occasions. Along with punish work, I also promise to call his parents and repeat, word for word, what he said. I wait just a moment for all this to sink in. Then I ask, "Are you clear on what I expect from you?"

Let us assume this young man gets it, that I am *serious*. He nods in agreement and says, "Yes."

"O.K. then, let's go back into the room so you can get back to your project." I say this in a calm, clear voice.

If I have enough time to work around the room, and I get to him again, I will help and encourage him, just as I have with the other students. I want my punishments to be swift and clear. *Do not hold a grudge. It will hang in the air, polluting everyone's mood.*

This young man will not be laughing as he returns to his desk. The other students will be quick to read his expression. He will not be interested in discussing our talk in the hall. There will be no more inappropriate comments made today.

The class will closely observe my next actions. I do not say a word about what just went on in the hall. I quickly return to my

good humor. I do not let it affect the way I treat the rest of the class. This class is going to see that I am one "pulled together" teacher.

Later, outside of class, his friends are going to ask him what went on in the hall. This is good. Now *they* can decide if it is worth playing games with me. The other students are glad they know where I stand.

Although it is unlikely, let us imagine that this Romeo *does* make another rude remark the next day. I call him to my desk, and hand him one of my punish work assignments. I remind him that it will be doubled if it is not completed by the time he enters class tomorrow. I make the necessary notations in my roll book to remind myself to collect it. I ask the young man to give me his home phone number, although I already have it. He knows why I want it, I told him yesterday just what I would do and I will call his parents this afternoon. If he gives me a false phone number, I document that too. I inform the principal in writing what has been said and how I am handling the situation. I am just keeping the principal informed on the problem and what I am doing about it. He may be called in on it later. I hope this young man is finally catching on! Of course, the rest of the class is quietly watching this whole procedure and they are making mental notes about whether or not they want to tangle with me.

The next class period I have with this student, I call on him to turn in his punish work. I have him quietly stand at my desk while I review it. If it is not done to my satisfaction, I tell him right then that the punish work is doubled and that it is due tomorrow. Once again, I speak in a controlled, yet firm voice. I make eye contact, just enough to make him feel uncomfortable. I note the doubled work requirement on tomorrow's roll. He watches me do this. I now send him back to his seat.

Please do not let this unpleasant job affect the way you treat the rest of the class! Brush this off quickly and move on to teaching. If this situation caused me to yell and create drama in the classroom, I would appear immature and ineffective. I posted the rules on the wall and reviewed each one with the class. *These are not stupid students.*

If on the following day, Romeo has not turned in the doubled work, I do what I said I would do. I write up a formal discipline report and explain that he was given two chances to do punish work for me and that he *chose* not to do it. I review the offense and what the student was required to do for punishment. A good principal will not ignore this. Most likely, the principal will give him some type of detention or even a one-day suspension. If Romeo has a long and troubling record on file in the office, he may even be expelled. How I handled this situation will have a long-term impact on how my students treat me. *Make an early commitment to earn your students' respect and to be a teacher they will remember as fair.*

I purposely chose our Romeo to make a borderline offensive comment. If he had said something more sexually explicit, I would have handled it differently. I would immediately send him to the principal's office. Just as swiftly, I write up a discipline report explaining the comment and have another student hand deliver the sealed report to the principal. Because this is more serious, I jump right past the punish work assignments.

If Romeo screams an obscene, sexually explicit, or threatening comment to me or anyone else in the classroom, I take even stronger measures. I use my intercom system to call the office to say, "I need the principal to come to the art room" or use a code you use for help. If the secretary asks who the student is, I tell her. *Listen to your inner voice that warns you when something is seriously*

wrong. Had I sent this student on his own to the office, he may have chosen to leave campus instead. He knows he has a lot to lose over what he has just said. It is better to have him escorted from your class. *Do not get into an intense argument with this student!* I do not know the whys of his behavior (drugs, psychosis) or the depths of his anger or to what ends he would go to rid himself of it. Let the more senior people in the office handle this one. It is not a reflection on you.

Male teachers are certainly no less vulnerable to The Test than are female teachers. A male teacher may get harsh comments about his physical appearance, his speech, or comments about his sex life. He may be challenged on his assignment requirements. He may get cursed at. He may be openly made fun of with the intention of making the teacher look small. He faces all the same things that a female teacher could hear. The way he handles The Test remains the same. *Do not ignore it; make a plan to handle it ahead of time.*

Tip 60: Derail Your Temper Tantrums

*A*nger *is an emotion you must learn to recognize at its beginning. The sooner you can derail your temper tantrums the better.*

I cannot say that I have not lost my temper. I have. When I have lost it, it is usually when the majority of the class is misbehaving and I cannot get the class's attention. This is an extremely frustrating situation! If I briefly raise my voice in anger, the students hush quickly. *They are not used to me being angry.* I will enter the center of the room and I will purposely look at each student as I calm down and I sternly explain *exactly* the reason for my anger. I take my time. Once again, I spell out what will happen if this classroom behavior continues. Some special classroom privilege may be taken away if the misbehavior continues. I explain once again what the goals of the class are for this particular day. Things will begin to settle down and if one or two students continue with the misbehavior, I can issue punish work to these students.

I believe if we keep our students informed about our expectations *we* are less likely to blow up. Most anger comes about when we feel we are being used, ignored, discounted, ganged up on, or disrespected. We may feel like a boiling pot for days, and we don't sleep at night. We have nightmares about students who are out of control. The same behavior goes on in class day after day. We don't know what to do about it. This is a formula for an explosion and when we explode, we can say things we should *never* say to students. Here is the worst part of it. If you are called into the office for speaking inappropriately to your class, you will

have nothing to stand on if 25 students say they heard you! Into your permanent file it all goes. In my school system, a teacher can get a layoff notice at the end of each of the first three years of teaching, before earning tenure. The system *absolutely has to give no reason for your dismissal.* I know many young teachers who were not asked back because of their anger. It scares your supervisors because they do not trust you.

Learn your personal signals that let you know when it is time to be firm and clear. Listen to tension in your body. I start to grind my teeth and tighten my jaws and I begin to talk in very short, curt sentences or phrases. I lose focus on what I am trying to do. I begin to fumble with things. I cannot concentrate on the sincere student who wants my help. Those are my warning signs. Take care of an unruly situation before it snowballs into an avalanche. Do not put off what must be done. The sooner you remedy a discipline problem, the sooner you can get back to your teaching, and the sooner you will get a good night's sleep again!

You may have had the best art experiences and art education in college, but it will not mean a thing for your career if you cannot control your temper.

Thought Provoking Questions **to Identify Your Anger Triggers**

I want you to think about your anger. Remember occasions where you made poor decisions because you were out of control. Can you identify your symptoms and signs that let you know that you are about to explode? Make a list of the telltale signs that your emotions are getting out of hand.

Tip 61: Avoid Discussing Personal Issues with Your Students

D o not discuss your personal issues with your students. Your students are not your captive audience. You must have adult confidants in place for the support you need.

In the thirty years that you may plan on teaching, you can be sure that at some time along the way, you are going to be blindsided by painful personal issues: a bad relationship, troublesome children, empty nest syndrome, mental illness, substance abuse, or a death of someone close. So will all of those teachers on the left and right of you. The good news is that a bad situation can be resolved and you can move on with your life. What will be important is to be prepared for unpleasant events, if that is possible.

Do not ignore your spiritual needs. Get involved with your spiritual community and its activities.

Build strong and honest relationships with mentally healthy people.

Develop long-term friendships with a few of the teachers you like at your school. Learn to give and to take in your friendships to allow them to develop and to deepen.

I know of what I speak. I struggled through a divorce. It was a devastating year. I was dealing with all kinds of insecurities. I was trying to provide a comfortable environment for my child and deal with new financial pressures. I moved into a new home. I had to meet new neighbors as a single person. There was always new paperwork. It seemed that I carried the entire world on my back. I needed a lot of support from family and friends. It was a good thing that I had that support!

If you isolate yourself from the adult world and depend on your students for your human interactions, you will be tempted to dump your crises on them. Do not attempt to obtain sympathy from your students. Do not try to be friends with your students.

What if you are suffering emotionally and you *know* that you cannot discuss your intimate problems with your students, yet you have no adult friends? This can create a serious situation for you. You will have to face this crisis all alone. How do you think *that* will affect your classes? You might become one of those angry, grumpy, mean teachers that you swore you would never become, just a ticking time bomb. On the other hand, you might gradually turn into an icy statue of a human who does not give or get from your students for the fear that you might feel an emotion. A hardened and deadened soul you may become, without even realizing it.

Please, surround yourself with loving, caring, and mature adults. You will need each other at some point in time. Your students are not the ones you pour out your intimate pain or joy to.

Tip 62: Approach Other Teachers about Possible Misunderstandings First

Stay out of the principal's office with your complaints and rumors about other teachers. You will look like a busybody or worse. If you have a problem with a teacher, try to approach that teacher one on one to clear up any misunderstandings.

Principals despise teachers who are regularly lurking at their office door with mindless gossip or minor problems. You are paid to work your problems out on your own as much as possible. When you cannot, then you ask your superiors for help. You do not gain favor from your superiors by trying to be in their presence every day. If you will follow this plan, you will find that when you do want to talk to the principal, he or she will be more attentive to your needs and concerns.

Here is a story about what happened to me when I was teaching sixth grade art.

My students were making circus figures out of white plaster gauze strips. It was going to be a long project. We built wire figures and layered detailed and refined gauze pieces on top of this basic form. The students would paint them with colorful acrylic patterns, once the figures were completed in gauze and completely dry.

A local artist was teaching private painting lessons in my room after school. The school board was promoting an enrichment program. Monthly sessions would be taught. She was a watercolor artist, and she was very good. We did not cross paths in the afternoons. I was not aware that she was watching the progression of the circus people so closely.

Each day we placed all of the in-progress figures on the windowsill to dry. One student was planning a wonderful pirouette clown. She had the basic body formed in loose pants and she had built the tall pointed cone onto the head. The next day, she was going to create a large crinkled collar and later would paint large dots on the clown's costume.

The next day, the principal called me into his office. The visiting artist told him earlier that she thought it extremely inappropriate that I would allow my students to make Ku Klux Klan figures in my class. How could I allow such a racially offensive figure to be made in the art class! This would never have happened where she was from! Maybe the parents should know just what kind of insensitive person your art teacher is! My principal told her he would ask me about it the next morning and so he did. I was livid! I showed him the "offensive" figure. He nodded his head in disbelief at the horrible assumption the woman had made. There is no telling how many phone calls she made to parents that evening. She did not have the professionalism, or the decency, or the common sense to ask *me* about the figure before talking to my principal.

The principal did not ask the watercolor artist to teach a second session.

Most problems between teachers can be resolved one-on-one, however, if a *student* ever tells a story of some physical or mental abuse from staff or faculty (or home), report it to a principal or guidance counselor as soon as possible. They know the proper legal steps they must take to investigate such issues. *The law requires all teachers to report such charges to our authorities.*

Tip 63: Imagine that Everyone is Related to Each Other

*A*lways assume that the child, who you are about to call an idiot, is a relative of someone sitting with you in the teacher's lounge.

Tame your tongue! It is hard to watch a teacher squirm and fumble for words after he finds out the child he just verbally demolished is a relative of a co-worker. The teacher (or the family friend) will never forget. I know how a bad day can make you want to scream once you are among your peers, but be careful of the words you use concerning a student.

I use a trick that keeps me in line. Before I say something derogatory about a student, I imagine, *would I be saying this if a relative of the child were seated across from me?* It is simply amazing how this image will affect my wording. I realize that I had better just say nothing at all. The lounge and lunchroom are not places where you should be gossiping or discussing students that you do not enjoy teaching.

I mentioned the work place, but this rule applies to any place you might want to talk about a problem student. I have heard of parents calling for conferences with the principal after someone told them about something a teacher said about their child in the grocery store or at a sporting event. There are big ears out there listening to what teachers have to say about students. You are closely observed in the community, whether you realize it or not. Not everyone likes teachers either. People may be looking for weaknesses in your professionalism.

So, what do you do when you need to vent, or ask for help with a difficult student, or one that gets on your nerves? You

need to make an appointment with a school guidance counselor
or an assistant principal that you like and with whom you can
communicate. Both of these professionals will listen to you.
They can offer support, helpful insights, or advice in a private,
confidential environment. You will feel better and no one gets
hurt.

Tip 64: Take Care of Your Health

T ake care of your health. Eat properly throughout the day. Learn to listen to your "slump times" and schedule meals, breaks, exercise, and rest to prevent these slumps at school.

You must get in the habit of eating a good breakfast. You will need fuel for those first few hours of the teaching day when so many important decisions are being made. Mornings seem to be high intensity times and you need a steady supply of energy. Avoid sugars and highly processed foods. Choose foods that are slower to digest. Chances are, if you wake up and you are not hungry, you probably are eating too much late at night. That evening meal will let you down sometime during the morning.

Commit to eating a light and healthy lunch. For many teachers, the heavy cafeteria food will put them in a fog in the afternoons. You will need to eat moderate portions of these meals. If you are famished because you have not eaten since the night before, you will definitely be vulnerable to eating heavy meals or fast, easy junk foods. Consider making your lunches at night or get up a little earlier to make them. This way, your lunch is waiting for you whenever you need it and you will not have to wait in a long line to purchase food. We were given 25 minutes for lunch. Who wants to spend 15 minutes of this time walking across campus and standing in a line?

Schedule regular restroom breaks. A doctor of internal medicine once told me that he had never met a schoolteacher who did not have some kind of an intestinal or bladder problem. He believed this was because we do not listen to our bodies during the day.

Exercise in the early morning or the afternoon. Much of your mental stress can be eliminated by taking a long brisk walk. Getting the blood flowing will reawaken your ability to come up with fresh ideas. I have come up with my best solutions to problems while taking a long walk. Make this as much a part of your routine as eating and sleeping.

Sleep. This is a serious problem for many of us. It is hard to manage a class of demanding students when you are in a mental haze. Aim for a regular time to go to sleep at night. Do not keep a television in your bedroom. Create a soothing routine to prepare for bedtime. Get your eight hours of rest every night. Your week will go *much* better if you keep a regular schedule for eating, exercising, and sleeping. Some of the problems you may be having at school can be the direct results of your neglecting your own health.

Thought Provoking Questions **about**
Exploring Your Past Eating Habits

Think about past jobs that required you to work at established times and for long blocks of time. Have you had times when you were negligent in managing your routine? Did you ever get warnings for being late to work? Did you ever feel incompetent because you were tired? Did you ever feel restless, nervous and irritable? Below, write observations about how you managed your routines in the past and how it affected your job.

My past pattern for eating breakfast on a workday:

My past pattern for taking rest room breaks at work:

My past pattern for eating lunch at work:

My past pattern for exercising on a workday:

My past pattern for getting eight hours of rest before a workday:

I will commit to changing the following pattern:

Tip 65: Think before Taking on Art Projects for Other Teachers

*C*reate a way to respond to those teachers who ask you to do their art projects.

If a teacher asks me to write three certificates in calligraphy, I will gladly do it, *if* I have the time to do it. I make a mental note that this is a person I will ask to return the favor in the future.

If a teacher asks me to write 60 certificates in nice calligraphy, well now, that is a different story! I have been asked to do this by a Physical Education teacher who wanted Participation certificates. She barely knew who I was. I think most teachers are clueless about how much preparation it takes to be a good artist. I think most believe that you were given talent and they were not. I feel they believe that you do not have to think to be an artist, but that you miraculously feel the talent and it appears instantly, with no effort at all. Bless their little hearts.

I told this teacher I would be glad to help, but then laid out what I would need from her: I would need about an hour or so of uninterrupted time to do this. I would need her to provide me with her roll, and add ten extra certificates for those names that I might accidentally misspell. She would have to buy the art department a new felt calligraphy pen because I would be using up a full pen. For me to do this, which I would gladly do for her, I would need her to come to my class on her planning period to watch my students so I could get it done. And then I smiled and waited. She truthfully explained that she thought it would take me no more than 10 minutes to do this for her. I wished her

luck and she went off to find another way to do this; maybe the computer could print out calligraphy certificates?

When others ask you to do something major for them, try to determine if they are just dumping on you. Are they truly in a jam and it is something you can do within reason and with a good attitude? Will your students suffer if you are pulled away to do this favor? Do you believe what you are going to do will benefit their students? Let this teacher hear the gears working in your head as you try to estimate how much of your time this favor will take. Be sure to discuss how long it will take to find suitable images to work from and to plan the project. Discuss with the teacher collecting supplies and, depending on the scope or scale of the project, measuring the space and rearranging your room. Explain about drying time needed, and what the teacher will have to buy for you. Try to estimate the number of hours this project will take from conception to completion. Of course this teacher will be willing to stay after school each day to help you, won't she? If not, *surely* she will come in during her planning period to help with your class while you are doing her project. Now we're talking! Find out if she is willing to make sacrifices for you to do her work. If not, politely say that it is just *too* time consuming for you to do at this time. She will not have the nerve to persist.

You have to see doing artwork for another teacher through his or her eyes, too. Did you ask this teacher to chaperone a dance sponsored by the art department last year? Did this teacher allow you to move the two extra students that did not have desks into their class? Did this teacher teach your class one period so you could go to a doctor's appointment? Did he take your nighttime chaperoning duty once so you could go to your child's recital on the same night? Did this teacher help

you cook and clean for a special reception? If this teacher has been generous to you, you are obligated to remember it and pay them back in kind. Do the art project for them and do it graciously.

CHAPTER 6: RELATING TO YOUR STUDENTS

Tip 66: Remember That Adolescents Aren't Finished Yet

*A*dolescents and teenagers are like baking biscuits; they may have risen, and appear to be done, but they are still just dough inside.

I remember very well when I was a new teacher teaching in junior high school. John Lamarque was a gruff, tough looking, teddy bear of an industrial arts teacher. He was approaching retirement at the time I knew him. I thought the students would be scared to death of him, but it was apparent that the boys and girls adored him.

During my first term at this new job, I cornered John at lunch one day. I was on a tirade about how many of the students just did not understand my reasoning about a decision I had made. I was tired of trying to convince the students that I was right about this issue. John indulged my ranting for a while before he finally told me a theory of his. His theory, he said, is that "Adolescents and teenagers are like undercooked biscuits; they may have risen, but they are still just dough inside." It made perfect sense, and gave me incredible peace of mind. I agree with his saying. I have faced many a student eye to eye and tried to deal with them as if they had the same years and life experiences that I had. Yes, some students do seem to be "old souls" and can comprehend many points of view. Unfortunately, many students do not. Just like a rising biscuit, they may have a fully-grown body, but their logic, reasoning, and long-term outlook are just plain "doughy thoughts."

Biscuits take time to bake to perfection and teenagers need time, too. Do not try to see eye-to-eye on everything with

them. Teenagers tend to be self-absorbed and they have not yet experienced enough of life to be empathetic. Adulthood is too far away for them to be concerned with long-term consequences. Try to enjoy this unique time in their lives. Teens add a real freshness to our "older" lives. Their innocence can soften our steely hearts. Their originality can shake up our understanding of their lives. Their humor as they describe us can be hilarious. Let yourself enter their world a little; it is an exciting and unique place.

When teens make humongous mistakes, and they all certainly do, remember that this is how they learn. Do not be too quick to rescue them from difficult situations and the subsequent consequences. If you are honest with yourself, I am sure you can come up with an example of a time when *you* did something based on foolish logic. It is from maturity and hindsight that you can see the reasons for the unwise decisions you made.

Dr. Michael G. Thompson, PhD, wrote a book called *Raising Cain,* in which he researched how boys develop. He presented his ideas on an episode of *Frontline* on PBS. He points out that even at 18, the frontal lobe in the brain, which controls risk-taking behaviors, is not fully developed in boys. They still need some forced boundaries.

To make a good biscuit, one cannot remove it from the oven too soon. If we try to rush the cooking time, we will certainly be disappointed when we break it open and find only dough. Let it bake slowly at an even temperature. It will become firm inside, even though you cannot see it happening. This is the only way to get a great biscuit.

Tip 67: Avoid Arguing with Teenaged Students

Teenagers were born to challenge authority, so do not take it personally.

Something happens to those darling little angels when they enter adolescence. They often become argumentative. As much as you may believe the arguing is about you, it is often an attempt for the child to establish an independent persona. This is a healthy thing. Try to stay out of as many arguments as you can with teenagers. Let the teenagers argue with other teenagers. Choose your arguments very, very carefully. Let the students see that there are acceptable ways to voice their differing opinions without being disrespectful or being loud. Listen to your students' differing opinions. You do not want them to be scared to talk to you. Some of your students will come from families where the child cannot have a voice in matters. Some of your students will come from families where screaming and cursing at family members is allowed. Some students come from families where they tell their parents what to do. Model for them a healthy example of how to "agree to disagree." You will be doing them a great favor.

Tip 68: Strive To Have Grace under Fire

*I*f you are not prepared to do it, then do not say it.

Unfortunately, students enjoy watching a flustered teacher. This usually happens when the teacher is frustrated, confused, and angry because she is not in control of the class. A teacher stammers, fidgets, and makes strange facial expressions as she throws out idle threats. She will fling her arms in a comical manner while nervously and awkwardly pacing around. This scenario is similar to kids standing around waiting for a fight to start at recess and laughing at the free entertainment. Do not play into these dramatics. *This is why you made that discipline plan you explained so carefully during the first week of the term.* Follow your steps carefully and you will have grace under fire.

Here is a frightening assignment for you to do: in private, ask a student whom you trust and admire, to describe to you your behavior when he has seen you angry. Explain that it is for your benefit to know. Ask the student to mimic you. Write below the scene your student described and you will find that seeing yourself through their eyes will go a long way towards you stopping your dramatic, nervous behaviors.

Tip 69: Gain Your Student's Respect

*I*f your students respect you, they will want to please you.

What a loaded statement this is, but how true it is. This is a big way to get students to love your class. Let us look for a moment at whom you respected when you were a teenager. Who was an adult you tried your best not to disappoint? Who was an adult where you stood taller in their presence, not due to fear but due to respect? Your responses did not develop in a vacuum. It was the result of interactions you had with these adults as well as *watching how they handled their lives.*

Let me tell you another story. I once substituted for an art teacher who had to take some time off. It was a high school art class. I walked in that morning and about five boys were standing at the windows at the back of the second floor art classroom. They each had handfuls of tubes of acrylic paint and they were squirting it out onto the first floor sidewalk. Everyone thought this was hilarious. They were screaming as if it was a sports event and they were scoring points. Every single piece of art that hung on the walls was crushed, torn or smeared. Some of the students were involved in a game of cards. Three students ran out of the door as I walked in. At the end of the day, I told the principal I would not substitute for her class again.

What can we assume about this art class? *These students do not show an outward love or appreciation for art.* It is painfully clear for anyone to see. We can assume that some of the students signed up for art hoping to have a great art experience. Unfortunately,

the bullies gained control of the class and the other students eventually gave up their dreams of art. It is now a holding pen for students. The teacher has probably given up, too. She may even blame it on the hoodlums sent to her. Yes, I have had some students that were awful, just dreadful. Systematically, it is my job to take steps to reform my students or to work with the administration to find another place for them. More than likely, some authority will tell you that the difficult students must stay in your class for the term and you will have to find a way to make it work. The school board pays you to be a professional teacher and a role model to your students. This is one more example of the necessity to train your students how to behave the first week of school. Do your job.

Here is an old proverb to reflect on—you might have seen it on the Internet or in your own email inbox:

A wise elderly Cherokee man was teaching his grandchildren about life. He said to them, "A fight is going on inside of me; it is a terrible fight, and it is between two wolves.

"One wolf is fear, anger, envy, sorrow, regret, greed, arrogance, self-pity, guilt, resentment, inferiority, lies, false pride, superiority, and ego.

"The other wolf is joy, peace, love, hope, sharing, serenity, humility, kindness, benevolence, friendship, empathy, generosity, truth, compassion and faith. This same fight is going on inside you and inside every other person too."

They thought about it for a minute and then one child asked his grandfather, "Which wolf will win?"

The old Cherokee simply replied, "The one you feed."

Thought Provoking Questions about What You Looked for in Respectable Role Models

Describe an adult you respected when you were young. Who brought out the very best in you? What set this person apart from other adults in your life? List their qualities that you would like to emulate. Pass these traits on to your students in this person's honor.

Tip 70: Walk Softly but Carry a Big Stick

President Theodore Roosevelt was right, "Walk softly, but carry a big stick."

Smile, be at ease, and make light jokes. Your students know that you *will* take control of the situation if the class gets too loud or off track for very long. You may have to take action to discipline someone, but after you do, get right back on task, relax and smile. It will take a lot of concentration on your part not to dwell for too long on a negative event. Your students will be aware of your effort. They always appreciate a learning environment where the mood and atmosphere is pleasant.

Trust the discipline plan you designed and vow to follow it.

Tip 71: Avoid Using Sarcasm with Your Students

N ever use sarcasm with your students. You will pay for it later when you find the students do not trust you with their ideas or their problems with their art.

The tone you set by using sarcasm is, "Okay, teacher, it's me against you, and *you* cannot be trusted. I will never let you embarrass me again like that, so I'll just shut down and shield myself from you."

Yes, you can tease your students *once you get to know their personalities,* but the bottom line is trust. It does work both ways, your students may not use sarcasm with you either. It is disrespectful.

At all times be aware of the atmosphere you are trying to create. You being a trusted adult and being consistent in your dealings with your students creates this comfortable learning and teaching environment.

Sociologist Michael G. Thompson, PhD, points out in his book, *Raising Cain,* that teen boys' behaviors are driven largely by avoiding things that could embarrass them. They are equally or even more conscious than girls of looking foolish. I am not saying that we should coddle and falsely build up our teens; I say that you can be honest and fair without using sarcasm.

Thought Provoking Questions about Your Experiences with Sarcasm

Ask yourself, and people whose opinion you respect, if you use sarcasm in your everyday language *and* if it is hurtful. Of course, the important point is this: *is it hurtful?* List any examples someone has shared with you about your sarcasm, now or in the past. What do you hope to gain by being sarcastic? Recall an instance when one of your high school teachers used sarcasm on you and the effect it had on you.

CHAPTER 7: PROMOTING YOUR PROGRAM

Tip 72: Be a Team Player while Promoting Your Program

*L**earn to promote your program and teach other teachers to value your courses. Help them see that your classes are as important as theirs are.*

Sometimes other teachers need students to do things such as make-up work, or special projects for school assemblies. I am reasonable about allowing my students to spend extra time in another class, if I have a note from the teacher requesting that student's time. I try to remember the big picture. We are trying to develop a well-rounded young adult. I am not the only important influence in my students' lives. Occasionally, a guest speaker will show up unannounced, or a student is responsible for escorting a visitor around school. I have gladly allowed students to finish their science experiments because the student promised to take their art project home to finish. You should be flexible, occasionally. You will certainly want to keep a student an extra 10 minutes somewhere along the way. *The important thing is to be sure where the student is and why a student is not in your class.* That requires a written request from the other teacher involved or an in-person verbal request to you from that teacher. *As long as a student is on your class roll, you are responsible for the actions of that student during that class time, regardless of where the student is.*

Now that I have encouraged you to be a team player, let us discuss the other side of this topic. If your classes have a reputation for being a waste of time, the teachers will automatically assume that missing your class is not important. It is an elective class and art is not a tested subject on state exams at this time, so we

are vulnerable to abuse. Even administrators will regularly take students out of your class to run errands. If five students are missing from your classes *each* day, yet they are on campus, just imagine your stress; what are these students up to!

You must put your students' work on display regularly. You must educate the students, faculty, and the public about the valuable things you teach in art. If your students constantly have something on display on campus and the displays change frequently, you will develop a large number of supporters for your program. I promise you this activity will be the *key* to earning respect for you and your program. *Few will question the importance of teaching art and few will pester you to borrow students from your classes.* Furthermore, your students will not want to leave your classes if they know their work may go on public display.

Tip 73: Create an Art Honor Board

*C*reate an Art Honor Board close to the main entrance of the school and in close proximity to the principal's office.

When I start at a new school, I request a large, cork, wood trimmed Art Honor Board. (This could be an industrial arts project). We place the board permanently in the main hallway. I know if I want respect for my art program, I am going to have to show the students and the community what we do. I have observed over the years that many people have negative opinions about art programs based on their experiences with poor programs. I have heard of programs where students were given two weeks to copy a picture of Mickey Mouse on notebook paper. I have heard of programs that used string art patterns for months and months. I have spoken to people who had art teachers who said, "Make something cool." Soon after, the students spent their time throwing pencils into the ceiling to stick and hang. I have not been a part of this, but you and I are lumped into this same category unless we develop a different, exciting approach.

The last time I started at a new school, I approached my new principal and I explained to him just what I have told you. He nodded vigorously in agreement. Within two weeks, the carpenter crew built my Art Honor Board. It was two large panels wide and trimmed in five-inch baseboard wood. The trim was neatly painted in the color of all the other wooden trim on campus. Now, here is the sweetest surprise of all, He had three spotlights installed on the opposite wall to add further importance to my display area.

"All right, Mrs. Johnt, show us what you can do for our school," he said to me smiling.

I covered the cork boards with black, bulletin board paper twice a year or when it began to fade, or when the push pin marks became too visible.

That Art Honor Board became a huge success! I (or responsible students) would change the art weekly. I made sure that *every* student I taught had at least one work put on display. Some weeks only three large pieces went up, other weeks twenty pieces might have gone up. We attached each piece of artwork to construction paper with removable tape. When I mount a piece of artwork, I like to have at least a two-inch border of color showing. I buy good, large construction paper in an array of colors for this purpose, including four different grays. Your Art Honor Board could be the first time students have had their work on display on campus since elementary school. They will make their friends come and see it. They will get their grandparents to come to school to see it. They will call their out-of-town parent to tell them about it. When the piece comes down, the art and the construction paper backing goes home and, in many cases I am sure, is put up on their wall.

I made a big point that this was not a "pity" board. I only displayed work that was well thought out and carefully executed. I used to tell all of my clases, "Remember students, this Art Honor Board reflects on me too! I will not have my name associated with shoddy artwork." Teens understand this and want to be a part of this philosophy. When others laugh at something a teen creates, it is just the worst experience for them. They recognize phony praise and they do not like it.

In the thirteen years I taught at this high school, not a single act of vandalism happened to the works on the Art Honor Board.

Tip 74: Create an Art Easel

*L*ocate an open area on campus for a large, sturdy painter's easel. Your Advanced Art students will use this Art Easel each week to display one student's exceptional work. Create a name banner for each Advanced Art student and use it on this easel.

Motivation! I cannot say enough about it. Traditions! Students love traditions. Students discuss the Art Easel and they have detailed memory of who has passed before. It is this sense of belonging to a continuum that makes school a pleasant experience. Create traditions in your art department.

By chance, the local Junior College gave us a huge, heavy, well-used wooden studio easel. Bits of wonderful, ancient paint covered it. I placed this at the entrance to the library. I used this for my Advanced Art students only. I stood canvases on the easel ledge and mounted lightweight work onto donated scraps of colored mat board using removable tape and glues. I made name banners for each student, with the words *Featured Artist: Jane Doe* written with a broad calligraphy pen. I would stand the banners, drawn on strips of poster board, on the small ledge designed to hold paints and brushes. The banners were approximately 5x24 inches. During the first weeks of school, I would begin making the banners. The students were excited to see them! There have been years when I taught calligraphy and I would let each student make his or her own banner. I kept these banners stacked in a clean cabinet. I did not want to rewrite them if they became soiled. When I (or the class) decided what should go up on the easel, I would simply pull out the student's banner and take it

with me when I placed the artwork. Because this easel was at the entrance to the school, visitors would linger at the works as they waited for their appointments.

This one little tradition allows student recognition at school in a bold, positive, and powerful way. Other teachers might make positive comments to the student whose work is one display. Administrators use this opportunity to offer praise to a student who may be struggling with grades or a poor attitude. Students bring their cameras to school so someone can take a picture of them standing next to their work.

This brings us to the discussion about the commitment to teach art to every art student. Because I made a commitment to display work continuously, I made sure that what I was teaching was productive! If my students were not putting out quality art, I would not have quality art to put up on display. If I were only putting up the works of a handful of students, obviously I would not be reaching the majority of my students. I would sometimes ask a class, "Who has not had a work displayed on the Art Honor Board or on the Art Easel this term?" I knew that these were the students who need a little extra inspiration, motivation, and attention. We would all work extra hard to make sure that every student produced something interesting to go on display.

In my classes, each student got to take home their name banner at the end of his or her Advanced Art classes. It became a tradition. *I have never found one in the trash.*

Tip 75: Plan Displays for Sculptures

M*eet with your librarians to plan exhibits for your three-dimensional art pieces. Ask where they would like the work to be displayed. Explain how much space you will need. Decide on a time to put up the art pieces and a time to take down the art pieces.*

I have been fortunate to work with incredibly generous librarians. These peers believed having art on display was good for them, too. It brings more traffic into the library. It adds personality to an intimidating place. Their enthusiasm helped me enormously. Some of the exhibits could be coordinated with specific subjects, such as placing architecture models on the counter top above architectural books and industrial arts books.

Do not assume that you can display a piece without discussing your vision with your librarians. Allow them time to think about it and to get back with you. The school library is used for many different purposes. The room is often on a strict calendar for activities such as state testing or guest speakers and for writing and researching book reports.

If you do put up an exhibit, be sure to place it carefully. Think about the traffic flow through the exhibit. Leave standard spacing between each piece. Make sure that each piece is sturdy and will not easily fall apart with an accidental bump. Do not stick the exhibit in a dark or secretive place where less-mature students might disturb the art pieces.

I exhibit every student's piece when I have a sculpture show. *I let the students know in advance of this plan.* Usually, I try to keep a 3-D exhibit up for two weeks. If I know the work is going to

be put on display, I will give each student a grade for creating a display card. The card will be carefully written with the student's name and the name of the piece. It will be lightly taped to the counter top in front of the piece. You would be amazed how sloppy and how many misspelled words a student will use if you do not grade their card separately from their art piece. I do not grade the card until it is taped down.

Type or write a display card explaining the goals of the assignment for the pieces on display. Stand this on a small table easel. Everyone enjoys looking at the work when it is understood what the students were trying to achieve. Save your description cards in a clean place so you can use them again. You may repeat this assignment another term.

Take photographs of your sculpture exhibits. You can use them for inspiration later. It is difficult to save large 3-D pieces in the art room. Create a system to file these photos on your computer for easy retrieval.

Your local newspaper, if asked, may publish the photos of your students with their 3-D art pieces. Take pictures of the class *making* the art, this makes the finished work more interesting to the readers. This is a good opportunity to get publicity for your program.

On occasion, I have assigned a student to critique each other's work as a written assignment and place the paper next to the sculpture he critiqued. I graded the papers not only on content, but also on grammar and structure. There are many ways you could decide who will critique whom. *Use this assignment as records of your efforts to improve the reading and writing test scores at your school.*

Tip 76: Anticipate Putting Up Large Art Exhibits for the Public

Y*ou may be asked to put on an art show at the end of the year. If you have been keeping an Art Honor Board, an Art Easel, and you have done library exhibitions this task will not be too daunting.*

Putting on a school art show can be a pure horror. It is time consuming, stressful, technical, nerve wracking, and deadline driven. I have put on many! You may get to decide when, where, and what you want to display in your large show. Lucky you. Often though, this is not the case. Every school administration has its own agenda or school traditions. Let me review some that I have been a part of: Parent Teacher Organization Open House, Arts Celebration and Demonstration, Spring Fling, Christmas Festival, Athletic Auction, Fine Arts Night, Superintendents Banquet, Hospital Fund Raiser, Heritage Day, Yearbook Breakfast. Whew! I will not even name how many I have politely declined.

If you are holding the exhibit off campus, you are tripling your headaches. When faced with this challenge, I always asked myself two crucial questions: How many people do I expect to see this exhibit and will it be worth the effort to pull this together? Works can be damaged during transportation. You may not get to put up the show during school hours unless the school will hire a substitute. You may have to rely on trusted parents to put up the show for you. Will the building be locked until you can take down the exhibit?

My principal came up with my favorite exhibit. He was very proud of his Fine Arts Department. He envisioned a night at the

school where each of these programs displayed their talents. The evening was well publicized and held at the same time each spring. At the school entrance, a huge dragon barbeque pit designed, built and painted by the welding students greeted guests. Upon entering the gymnasium, guests were offered cake, punch, and treats created by the consumer science classes. Guests signed the guest book. A big welcome banner and the Art Easel were at the entrance. Inside the gym, flat art works were hung on standing display boards, sculptures were on tables, creative writings and photographs were displayed. The school band played from a stage set up on the gym floor. The chorus, dressed in their finest, sang throughout the evening. The drama students put on acts from their plays. Even the computer program had an exhibit of some of their creative projects. Guests were encouraged to walk around with their food and drink to look at the exhibits and talk as the music played. If they preferred, they could sit in the stands and just watch and listen.

This exhibit was a huge hit with the community. We had hundreds of people attend. It was *fun*. People who normally do not enjoy "artsy" events had a ball. People laughed and old students returned to see what was going on at school.

I required that every student I taught during the spring term put a piece in this show. I issued a grade to each student; 100 if the work was in the show or zero if the work was not. Each student had work already displayed on campus at least once during the term. Their work, which was already mounted on construction paper or already had a display tag, was ready for display.

Thought Provoking Questions to Determine Art Exhibit Areas

1. Where would be a good location for an "Art Honor Board" on my campus? How large do I want it? Who could build it? Can spotlights be aimed at it?

2. Where could I get a large, sturdy art easel to use for a permanent display? Where could I place this easel where it is highly visible, safe, and close to school official offices?

3. Who are the local frame shop owners who may be willing to save large pieces of scrap mat board to be used for mounting works on the Art Easel?

4. Where would be good places to exhibit three-dimensional art? Who are the people in charge of these areas? Have I met them yet?

CHAPTER 8: THE ART OF TEACHING

Tip 77: Spend Time Motivating
Students' Interest in the Project

S pend time motivating the students' interest in the project before starting it.

Many times my student teachers would begin a project so quickly that the students appeared puzzled about where they were going to go with this new assignment. It looked like drudgery as the students went through the motions. A better way to introduce new material is to show examples of what you want the students to achieve. Show examples of work done by famous artists and discuss what the artists were trying to convey to the viewer. Set up the project with a lot of thought provoking questions and discussions. Explain how skills learned in this assignment will be the foundation for other skills. Show them what they may eventually be able to do with these new skills. If you have taught the assignment before, show several different solutions to the assignment and then *explain* why each one is successful in its own unique way.

For example, let's say I am still teaching and am about to teach life drawing. Before I jump straight in to human figures, I might teach a unit on Michelangelo and his frescos in the Sistine Chapel. We discuss the foreshortening of figures in this painting, and the lively rivalry between Michelangelo and the Pope. I discuss my own visit to the Chapel and my awestruck reaction to the frescos. We discuss Michelangelo's self-portrait and the image of the priest who Michelangelo disliked. I make the frescos exciting. I make the artist interesting. I make the students want to be Michelangelo.

Aside from just introducing Michelangelo, I might also give students pictures of skeletons drawn on paper. I have them draw skin around the skeletons using as references drawn images from the Renaissance. (I grade these drawings.)

From the photographs of people in magazines, I have students measure with rulers the height of the skull in the photographs. This is to prove that the human body has seven and one-half segments. Each segment is equal to one head high except the ankle, which is ½ head high. Exaggerate the length of the body from the waist down and the person looks grander.

In other words, we *focus* on the assignment before we jump right in. By now, every student is excited about trying to draw live figures and they are ready to get involved in the assignment.

If we finish a project with mosaics on one day, and on the next day I say we are drawing humans, there would be a lot of complaining. Why? It is because the students are scared that they cannot draw humans. Give them some time to get used to life drawing, and a little time to develop an appreciation for life drawing.

Tip 78: Give Praise Before Criticism

G*ive specific, sincere praise for a part of a student's artwork before you offer suggestions for improving the weaker areas of that work.*

Each time I approach a student while he or she is working on an assignment, I take a moment to scan the art. I am looking for something positive to say about the artwork. It may be about the composition, the emotion communicated, a pleasing color scheme, or using a quality technique, a point of view that communicates well, but it must be a sincere comment. I love to refer to a previous attempt by the student, and I point out why the approach he is using is better. Students are pleased to know you remember their past work and that you are keeping a mental track of their progress. This is an example of what I mean: "Perry, I see you are much more successful now in drawing the back of the skulls fuller. I see you are remembering not to cut off that part of the head, and your drawings are stunning."

When students *expect* you to say something nice about their work, they will look forward to your coming by to make suggestions. After you have said something *sincere* and *positive* about this art, the students will be open to the suggestions you make about an area that needs more work. Let us go back to Perry again: "Take a moment Perry, and recheck the size of the ear. Look at your model out there. Where does the bottom of her ear end in relation to the corner of her mouth?" Wait patiently while Perry looks for the answer. He tells you that the ear is too long as it relates to the mouth. "That's right, Perry, your observation

skills are getting sharper. Now, redraw the ear and see how that looks."

I can now move over to help the next student. Perry received my time and attention and now he is happily continuing his drawing. You will often need to point directly to the area that is "working" and point directly to the weaker areas. Students may not understand the language you use, but they will understand what you mean when you point.

After I find something to praise, I will sometimes ask the student if there is something they do not like about their artwork. What they do not think works might not be what I do not think works. I try not to rush my opinion. I will assist the student with what is troubling him at the time. I might offer *my* critique of a problem area the next time I circle the room. You will eventually get to know each student's learning style. Some students want a lot of suggestion so they can move along. Others will want to be left alone to experiment, fail, revise, and succeed. Each artist is different, but each young artist needs your praise and your observational skills to assist him or her.

Tip 79: Show Exuberant Joy for Student Success

*A*lways show exuberant joy over a student's successful artwork. *Be happy and excited for them, the students will respond to your expressions of joy.*

You might be surprised to know that students are happy to know that you love your job. When you share in the joy of a student's spectacular work, it creates a warm bond between you and your students. My students just loved it when I got excited about their artwork. Now, this must be a sincere response. *Nothing can destroy this bond faster than phony praise.* For some unknown reason, adolescents and teenagers seem to be able to smell phoniness! Your personality is unique and different from the other teachers. In your own way, share with your students your love of art and your love of teaching art. You may never know which students come from homes where there is no praise for their creative and unique ideas. You may give a child their only opportunity to see an adult respond *positively* to what they have created. Nothing about your job could ever be as gratifying as this, I promise.

Tip 80: Review Yesterday's Assignment Everyday

E very day, after roll call, stand in the middle of the room to review yesterday's assignments and ask questions that will require the students to recall what and why they did what they did.

This is an old technique called *focusing*. I cannot overstate its importance to you. I definitely make leisurely time for this procedure. Here is how I do it: Once I call roll, I walk into the center of the room facing the students. I walk around and ask easy questions about yesterday's assignments. I randomly choose students to answer these questions. I want all students to be on their toes. I like to keep the previous day's assignment on the board for one extra day. This serves two purposes. First, any student who was absent yesterday will see exactly what he missed, and he will need to do this missed work to catch up with the rest of the class. Second, I refer to yesterday's assignment as I review what we did. In other words, two days of assignments are always on the board. You may think this is only to benefit the students but it sharpens your memory too. Your students will be quick to point out to you that you have not explained what you thought you had explained, because your other classes may be ahead or behind. Here are a few samples of questions I might ask:

"Kevin, yesterday we began to lightly sand the surfaces of our sculptures. Why do we need to do that? Wait for Kevin's description of how paint will not stick to a slick surface.

"Karen, why is it necessary to apply white under areas that you may want to be bright yellow?" Hopefully, Karen will describe

how transparent yellow is and how the under color will show through it.

Yesterday's assignment, which I wrote on the board the day before, says that I will demonstrate a light sanding technique. Next, I will show how to apply white gesso paint to the sculpture. My next question to the class may be, "Jacobie, where do we keep the sandpaper?" Jacobie points to one of the center cabinets.

"Eloy, why do we have to wait for the gesso to dry before we add our acrylic paint?" Eloy explains that the gesso will prevent the acrylic paint from being shiny if the two mix when both are wet. "One more question Eloy, where is the example of how it will look if these two paints mix?" Eloy point to the demonstration sculpture I did yesterday. "Very good, Eloy. Are you ready to paint?"

"No, I have to do a little more sanding and dusting first." he says.

I do not introduce new material before reviewing what we did during our last class. Never forget that your students have cobwebs in their brains about yesterday's class. They come to your class from all kinds of intense situations just *moments* earlier. They may walk into your class and still be befuddled by a complicated algebra equation. They may have, just minutes ago, broken up with a boyfriend. They may have just finished a history test where they had to list all the U.S. presidents. They may have gotten to lunch late, did not get to finish eating, and are still hungry and irritated. They may have just run six laps around the field house because they failed their test on the rules of volleyball. Whew! It is hard managing a day in school.

If you will learn to focus at the beginning of each class period, you will not have to go around and re-teach everyone one-on-one. *Sweep all those cobwebs off at one time.*

Tip 81: Speak to Each Student Everyday

W*alk a regular path around the classroom everyday and speak to each student. Briefly review each student's project and discuss his or her special concerns.*

You should budget your time each day so that you will have time with each student. The number of students in the class will determine how much time you spend with each student. My students know they will get a little time with me every day. Their problem is no different from that of a child in a large family trying to get time with a parent. The student must decide what their most important question will be because they know they will only get a few moments of my time. I often announce to a class, "Have your questions ready for me when I get to you."

By working in an alphabetical order, no one can accuse me of showing favoritism towards any student. I must speak to each student. Yes, it *is* easy to feel more enthusiasm for some clever students. You will need checks and balances to keep yourself from ignoring those children who are slower and less talented. I remember a time when a student almost jumped out of his chair when he finally managed to hold a paintbrush in a way that the paint went where he wanted it to go! Everything changed for him after that, all because we sat together and worked on his technique until he got it. Sure, teaching students how to hold a paintbrush is not very thrilling, but I might have missed sharing a wonderful experience with this young man if I had passed by his desk that day. Working just with the more talented students is seductive, and you must have a plan on how to avoid it. If I cannot meet

with each student in a class period, I will announce to the whole class something like this, "Students, it is time to clean-up now, tomorrow I will begin with Brenna Stevens." Oh yes, all of those students *beyond* Brenna will remember what I said, and *God help me* if I back track to someone I helped the day before!

We have all experienced life changing moments. Here is one of mine. My daughter, Alaina, was a thoughtful, smart five-year-old child. I was standing in her bedroom one day and she looked up at me with the most beautiful large blue eyes I have ever seen. Alaina's eyes were misty with soft tears as they were slowly meandering down her little face. Her blond bobbed haircut framed those heartbreaking tears. This wise child locked her eyes up on mine and quietly said, "Mama, you don't smile at me anymore."

I felt struck with lighting and I was nauseous. Really. Looking down at my precious little girl, I promised her right then that I would always look at her in the face and listen and smile. I was not aware that my face had been announcing clearly the worries in my life. She was feeling dismissed by me. Invisible. Unimportant..

She was the most important person in my life. I would change the way I presented myself to her. This event carried over into my sixth grade art classes that year. I saw each of these children as I saw my Alaina with her quiet tears. *At some point, I looked into every face and I smiled at each child every day.* It was part of my apology to Alaina. I found it was not hard to do! It became second nature to me immediately. Occasionally, I share this story with my high school students. They usually just smile back at me gently and we share a quiet moment as a class.

Tip 82: Teach Students to Handle Their Mistakes

There is an old folk wisdom that goes like this: "What is the difference between a good carpenter and a bad carpenter? A good carpenter can cover his mistakes."

Let's say that two carpenters have each been contracted to install fireplace mantles—one is a good carpenter, the other is a poor carpenter. A good carpenter certainly makes mistakes, just as a poor carpenter will. The difference is that a good carpenter can cover or camouflage the mistakes by making a series of adjustments, such as extra embellishments. As an example, I draw on the board a fireplace with two columns on each side of the mantle. I will make one column slightly different from the other. Next, I stand back and look at the two, and I explain to the class how I could add overlapping pieces to each column to make them look like I had planned it! In fact, the fireplace actually looks *better* than what I had originally planned. This is fun to do at the board. I draw another fireplace and make another mistake in the matching wooden columns. I will call a student up to explain how she would add wooden pieces of embellishments to make them match. One student may suggest that adding round medallions on each column will solve the problem. Another student might build out extra baseboards on each column to cover a miss-measured panel. The students love to explain their reasoning and if they run out of ideas, I will step in and help. Another "mistake" to correct could be a chair with four different length legs. How could you alter these to be even and look like you planned them to look this new way?

What does this have to do with me as an art teacher? Let's say a student drops a dot of black ink onto his artwork. You might offer that the student turn that area into a dotted pattern design. There is a good chance that with the pattern, the drawing becomes more interesting! A student's first impulse is to wad up her artwork and pout. This drives me crazy. Teach your students not to panic over a mistake. If they will just keep calm, they may just come up with something unique and spectacular.

My point about the good carpenter is this: *Everyone* makes mistakes in art, but just like a clever carpenter, no one has to *know* you made a mistake. Take the time to discuss this with your students. You will eventually hear a student call out some day, "Look! I'm a good carpenter!" Moreover, the other students will laugh, too. Let us face it, a majority of your day revolves around your having to help students learn from their mistakes. You want to imprint on your students that mistakes are not necessarily bad.

Thought Provoking Questions **about**
Drawing a Better Fireplace Front

Just for practice, draw four different ill-matched fireplace fronts on this page. Go back with a different colored pencil and show a way to disguise the imbalance in an attractive way. Try to make the new fireplace fronts more interesting than the original ones.

Tip 83: Do Teacher Demonstrations

D*o short teacher demonstrations by having the whole class stand near you. Demonstrate how and why a technique will work.*

I recall being extremely intimidated by doing this when I first began teaching. I was nervous and awkward. I never seemed to accomplish what I was trying so hard to show. Luckily, I have adapted by being the first person to laugh about my demonstration mistakes so the students laugh with me. Sometimes I drop a paintbrush or I will do *exactly* what I say not to do. I have splashed water on students accidentally on a regular basis. I will pull in an innocent student to help me with my crisis and that adds humor. I do try to make my demonstrations lively and entertaining. Remember, these students are close to each other physically, so you had better have something interesting to offer or you will lose their attention quickly! Try telling a funny story on your first experience with the new medium you are demonstrating. Try imitating the accent of a fascinating professor you have had. Exaggerate the examples of what *not* to do with the new medium that you are introducing. Be sure your voice has volume and an interesting tone and cadence. Share with the class what you are thinking as you explore the medium or technique. Let them see and hear how artists think and work.

When you do a teacher demonstration, it is crucial that you make eye contact while you work. These demonstrations, where the students tune into what you are saying and doing, will ensure that they understand what you expect of them. *You will not have to keep repeating yourself later if you do a good demonstration! Take*

your time. You want a quiet environment when your students begin to start their assignment. They need quiet time to think it out.

After completing the demonstration choose two students (randomly, or pick students who did not seem to be paying very close attention) to repeat your demonstration. Sometimes this is funny if the student is clever and can imitate you. Usually the student will have a problem and this will give you an opportunity to discuss something that you did not cover earlier. You are not making fun of the student, but you will gently guide him to a solution. All eyes will be watching how you solve the problem. This *reinforces* the new information you introduced.

My students *know* that I will choose two students to redo the demonstration; *it is a guarantee.* If a student is apprehensive about performing in front of his classmates, he is going to be paying very close attention to my demonstration.

At the end of the demonstrations, ask, "Are there any questions?" Give time for them to collect their thoughts. Remember, if one person asks you a question, three others may have been too shy to ask it. Dismiss the class back to their desks. They will be anxious to start their new project, and *fifteen students asking questions will not surround you.*

Thought Provoking Questions **about Your Intentions as a Teacher**

The Golden Rule, "Do unto others as you would have them do unto you," is a code for living familiar to most churchgoers as part of Jesus' so-called Sermon on the Mount. This code is simple, yet profound. Below, write out a meditation or a prayer focusing on your intentions as a teacher:

Tip 84: Plan Ahead for the Early Finishers

K*eep a collection of reproductions of masterpiece drawings for "early finishers" to copy.*

One of your ongoing problems in managing your class is keeping the early finishers occupied with relevant activities. I found that Dover Publications offers inexpensive booklets containing black and white, 8x10 inch reproductions of ink and graphite drawings by Michelangelo, da Vinci, Picasso, Munch, Mondrian, Goya, Shaun, and many others. You can divide these visuals into landscapes, portraits, full figures, or by style or era. The copies that my students produce are of their own choice. I find students will work diligently on what they choose. I do not grade these copies, but I do offer suggestions and encouragement. Incomplete drawings are kept in the student's shelf and can be worked on anytime he has extra time. This way a student gets a chance to try a new way of applying his graphite or creating a more dramatic shadow by duplicating a Master's technique. It is a good time to see just how far a good composition fills a page. A student may begin to understand the importance of accurate muscle structures, or the emotional impact that inaccurate muscle structure creates. This is a win-win situation. The students enjoy this engrossing activity and you can help the other students who are finishing the assignment. Do not forget that copies of another artist's work cannot be entered into competition. Use them only as learning tools.

These "masterpiece" reproductions make good assignments for a substitute teacher too. Put some of these copies in your substitute folder (see Tip 21).

Tip 85: Address Inappropriate Subjects
or Themes Used by Students

D*o not allow students to include gratuitous, provocative, risqué, or inappropriate references to sex, drug use, alcohol use, gender roles, racial topics, or religion in their artwork.*

Well now, it looks like a good time to pull out the dictionary! I used *Webster's High School Dictionary* to help me come up with clear meanings for these four, good adjectives:

- Gratuitous: Not called for by the circumstances. Unwarranted, unjustified, unreasonable, uncalled for, wanton, needless.

- Provocative: To arouse or stimulate. Aggressive, confrontational, offensive, insulting.

- Risqué: Bordering on impropriety or indecency. Off-color.

- Inappropriate: Not suitable, fitting or proper. Wrong, out of place, badly chosen.

Early in your career, you will have to deal with inappropriate images created by your students. Often, it will happen in the very first week with your class. *Be prepared*! Your students will challenge you just to see how far they can go with their images. They want to see what kind of reaction you will have to their

naughty or offensive creations. Do not worry; they try to test their parents like this, too. For many students, it is just part of growing up.

Once I see an offending image, I realize it is time to write on the white board the four adjectives I have listed above. You can have your students look up the words, or you can write the definitions and have the students copy them. The important point is to discuss each word and how it relates to creating art in the classroom. I do not overreact to this whole subject, but I make it clear that I will not tolerate insensitive art creations.

What do I do if I find a student creating inappropriate art? I take it and keep it to turn into the principal or I call the parents to discuss the art. *Most importantly, I let the students know in advance that this is what I will do if I find inappropriate artwork.* This is why it is crucial to discuss what you, as the teacher, find offensive and inappropriate. You must follow through with your promise and not ignore the offending artworks. If you do, it will turn into a game to see who can get away with the worst images possible. If the principal has not been to visit your classroom in six months, see how quickly he shows up to watch you teach when he hears that the students are creating inappropriate art.

You are the grown-up, and you know when an image is necessary to make a social comment or when an image is inappropriate. I love *Art News Magazine*, with current and past art works printed in fabulous clarity. The magazine covers all styles, techniques, and radical ideas. When I was teaching, I still had to remove many of the images found in *Art News*, as some of the images are inappropriate for schoolchildren. Even if you are vigilant, sometimes, one might slip past and a student will say, "Mrs. Johnt, I just found a risqué picture you missed," or, "Mrs. Johnt, I feel this picture has gratuitous images in it." The joke is

that the students would never have used such words unless we had discussed them in class. Don't let this fluster you. Instead, walk over to the student, and remove the picture right then but in a matter of fact manner. The same attitude applies to computer access in your classroom. Sometimes the image must go.

Students need to get enough attention from you so they do not need to create inappropriate images just to get your recognition. If the atmosphere you create is nurturing and productive, your students will respect you, and not want to provoke you.

Tip 86: Be Prepared for Bad Days

B *e prepared for that wretched day when you are an empty vessel with nothing to give.*

Yes, you can count on it. One day you will get to school and you are ill. You just cannot carry out your lesson plan. This is when you will be glad that you have a few priceless videos. These have educational merit and do not require "anything" from you. These videos can hold the interest of all students. I love the original *A Dog of Flanders* starring Alan Ladd, Jr. Filmed in Holland in the early 1960's, this movie's color is beautiful. The story is about a poor 12-year-old boy who wants to be an artist like Rubens. The students get to see the scale of Rubens' actual altar paintings. The language is rather dated, but the kids love this one, even if they laugh about it.

David Macaulay, the bestselling author and illustrator of the book *The Way Things Work*, has an illustrated video series released through PBS Home Video. You can find individual episodes for sale on the internet—look for his titles *Pyramids, Castle, Cathedral,* and *Roman* City; they are very entertaining and educational. Each program is action packed and explains the construction and purpose for these structures.

Silly, silly, silly is Mark Kistler's *The Draw Squad Classroom Video Series*, which is based on another popular PBS series, *The Secret City*. The students will need drawing paper and a pencil to use as Kistler teaches the basics of cartooning. Sometimes it will be necessary to rewind the tape or DVD to follow the more complex drawings. Kistler introduces shading in a fun, yet accurate way.

You probably have ideas for a few other videos that you find interesting that relate to art. I strongly suggest that you stay away from pop culture favorites that the students will beg you to show. These types of movies drive parents and the community crazy when they hear this is what you are showing. *It is just the excuse they need for the community to say, "School is just a baby-sitting service."*

Tip 87: Invite Guest Artists into Your Classroom

I nvite guest artists into your class as often as you can. Other artists may give the artistic spark for your students that you cannot provide. Do not let your ego get in the way of providing your students with a well-rounded exposure to other artists and their ideas.

My school system once had a grant to pay local artists to come and visit the art classes. It was an unusually successful year for me and for my students. Here are some of the interesting artists we had visit our classroom:

- A silversmith: This artist brought in her raw silver squares and demonstrated how to construct jewelry. She described her inspirations from nature and how she knows when a piece is finished. She allowed the students to try working with the silver.
- A book illustrator: We brought in an artist who worked for Cabbage Patch Kids, a doll brand based in Georgia and very popular in the 1980s. She explained the training of an illustrator and the strict size requirements for depicting the doll exactly to scale.
- A pinhole photographer: The artist allowed the students to use her oatmeal box camera. She explained how the dreamy, hazy quality of the prints was far more expressive to her than the hard-edged color photographs to which we are accustomed.

- An etcher: This artist brought in the plates, bees wax, metal tools and examples of past prints. He demonstrated the "bite" created by acids and how this affected the line quality on the prints. He explained the unique qualities of etchings and how to ink and make multiple prints. He explained the ethics of selling prints and how to sign and number the works. His interest was in old trucks and cars as themes.
- An architect: We had a local architect speak about how to use environmentally friendly materials and his responsibility to the environment. We saw blueprints and photos of the local buildings he had designed. He discussed the education required to be an architect and the math classes needed.
- A portrait artist: The artist brought her pastels and did a demonstration on two different models with different skin tones. She explained the importance of cool and warm colors and high key and low-key colors. Her freedom with color and layering the hues was wonderful to watch. The students drew one of the same models using the classroom sets of pastels.
- A potter: This potter was wonderful. He was large and burly and lived in the country. He brought his wheel and demonstrated his finesse and his strength with the clay. We saw the progression of his pots leading to a style he now favors as an artist. A few students sat at his wheel and tried to throw their own.

Keep your eyes open for artists who may come visit your classes. Your first place to look is your friends and you can repay the favor somehow. Your second place to look is the parents who

have children in your school. This is a good way for a parent to be involved in their child's education. A third place is local artists who have businesses in town and will benefit from the publicity you provide by telling the newspapers of their visit.

Tip 88: Count and Inspect Supplies
before Beginning a Project

*C*ollect, spread out, and inspect all supplies needed to complete a new project before you introduce it to the class.

In your excitement to start a new project, it is tempting to jump right in with enthusiasm and describe what you will teach the class next. You have the class all worked up to get going, only to discover you are missing key ingredients to successfully complete the project in a fair and timely manner. It is a disaster to be two days into a project and realize you are missing materials that cannot be substituted. I have been guilty of not counting supplies beforehand, just like many of my student teachers, and I have regretted it. I then had to work twice as hard to come up with clever ways to teach a different version of the project. If you find yourself in this position, you will have to grade the revised version differently.

Imagine these situations: Do you think ten students could share one pair of wire cutters? What would the others be doing while waiting for the cutters? This is not a pretty scene. Do you have enough nails to secure every sculpture to a base, assuming three nails will be needed for each sculpture? What will you do for the three students who did not get a nice beveled wooden base to display their wire figure sculpture? What will you do for the two students who were absent when you handed out the four-foot lengths of soft wire? Is it fair that these students only get one foot of wire each from what is left over? What if the new wire you ordered this year cannot be cut with the wire cutters you have?

What if your old jewelry tools cannot make the bends you feel will be necessary for this particular project?

As a rule, I find that tools can be shared easily only between two students. This includes things such as hammers, pliers, wire cutters, water buckets, files, rulers, and compasses. If you find you have students just waiting around, you are asking for trouble.

Calculate the number of tools needed based on your largest class that will be doing the project. For example, if your largest Art 1 class has 28 students, you can assume that you will need 14 wire cutters, plus a pair that can be checked out and a pair for you. Materials like paper will need to be counted out per student attempting the project, such as 75 sheets of Bristol board paper in 11x14 inch dimensions. You don't want a handful of students doing their project on bond paper because you ran out of the good stuff.

Take the time to get it all together! Everyone will enjoy what he or she is creating if not frustrated by dealing with a lack of materials. You, once again, are free to teach, inspire, provoke, and listen to your students during that magical class time, instead of searching for substitute materials behind twenty cabinet doors.

Tip 89: Revise Deadlines to Discourage Goofing Off

*L*ook around your classroom periodically and note the number of students who are distracted. If 50% or more of the students are goofing off, move the project deadline up a day. Announce that all of the projects will go on display on campus, along with its creator's nametag.

Nothing motivates a student like knowing that other students will be looking at something he has created. No student wants to think that others will laugh at or be bored by their creations. Just watch how fast students get serious about their creations once they hear *all* art projects will be publicly displayed!

Even after a full career of teaching art, I cannot predict, to the day, how long a project will take from start to finish. So many factors influence deadlines. This is especially true when you are trying something new (You should always be trying something new). I seldom had to move up a deadline by more than one class period.

A final note: If you say that all the works will go on display, be sure that you follow through with it. *If you do not mean it, then do not say it.* Your students keep a running tab on how often you do not do what you say you will do. It is a weakness they spot early and they will use this weakness to manipulate you.

Tip 90: Learn and Use the Language of Art

L earn the language of art and use it every day.

Variety, emphasis, texture, pattern, and value are the important words in the discussion of art. The elements and principles of art are your foundation of art terms. Put up posters for you and your students to see and be reminded to use these precise terms. Your students deserve clarity when you are trying to convey an idea. Besides, one uses these terms in all art classes one may take.

Students want to know proper terms. Students will respect you for teaching them the words that the art world uses. It is a confidence builder. I regularly hear from former students who tell me that their college art professors know that they had a good high school art teacher. Why? My former student, Kinzie Dudgeon Harvell, tells me that "Because you were comfortable discussing art and you could precisely explain visual ideas, now I can discuss visuals too" (see Tip 93 for more about Kinzie). I know you would love to have a former student to come back and tell you the same thing.

Tip 91: Play Music in the Classroom

B*egin collecting medium tempo instrumental music to play in your classroom.*

Studies show music enhances creativity when it is played in a tempo that is the same as the human heart beat. The study shows that this tempo will encourage relaxation as well as creative thinking. In fact, if you search for it, you will be able to find CDs created just for this. My students liked them. I do not like lyrics in the music because I have to step over and turn it down if I want to talk over the singer. You do not want to compete with music. This is the problem I had with classical music radio stations. Sometimes the advertisements would be annoying, although I must admit, I enjoyed some of their comments about particular musical pieces and the breaking news stories.

Keep your music system behind your desk where only you have access to it. If it is far from your control, you will find you are suddenly listening to something that will shake your teeth loose. What you want is background music.

I recommend ethnically diverse music if you can find it. I love the exotic sounds and rhythms from other cultures. Students can get lost in this otherworld and it can encourage deeper thinking. I love jazz, too. I *really* love jazz. Eventually, my students began to request particular artists. Easy listening music works, if that is what you enjoy. Most importantly, you want to listen to what supports your upbeat mood, and not music played at a frantic or irritating pace.

If you are at home, and you are in your own studio, that is a different story. Blare away with whatever keeps the mood going. At school, the walls transmit sound too easily and that will disturb the teachers near you. Not only that, but not all of your students can stay focused when the music is too stimulating and some will not have the self-confidence to ask that you stop it.

I once went on a teaching job interview and the second question, right after the question of had I taught high school before, was this: "How do you feel about your students playing the radio in your classroom?" Now, I felt like this was a trap! I did not think he would be asking me this unless it had been a problem before.

"I would only allow music that I feel is conducive to learning, not to partying," I answered. "I would be the only one to choose the station and I would be the only one controlling the volume. I would not play it every day because sometimes we will be discussing our assignments."

He offered me the job that very day.

Tip 92: Promote Environmental Responsibilities

W*ork with your school's science department to create projects that promote environmental responsibilities. Create a project that follows this theme year after year.*

I had the pleasure of working with a wonderful environmental science teacher, Judy. Judy planted dozens of native trees on our campus. Every year my art students would go into this arbor to draw and paint. It was inspiring to work in this rich environment of new and old growth. We used linoleum block prints based on these studies to make sensitive Christmas and holiday cards. Some years the students wrote original poetry directly onto their drawings, many were chosen for school publication. Sometimes the students did blind contour drawings and worked with Fauvist color schemes. Some years, the assignment was to draw their studies within a large circle composition and paint it in analogous colors of tempera. On each study, we would write the proper botanical name. That was *required* every year. We carefully captured the veins, bark and leaf patterns of each plant. Depending on the season, we captured the flowers, leaves, or the seedpods. Some focused on the abstract qualities of the leaves caused by insect impact or diseases. Some focused on the scale of a human under a gigantic, ancient, live oak tree. Some created dreamy vague worlds that begged the viewer to enter. Some made statements about the environment and about littering.

We displayed these drawings and paintings every year. We displayed earlier drawings, from our archives next to a new

drawing of the same tree. This was fascinating for the students to see how "their tree" had grown.

In this way, I promoted appreciation for the environment. The art department is a perfect place to promote environmental responsibility and appreciation. I cannot imagine any of the students involved with the tree arbor programs ever being involved in causing environmental harm. *Appreciation and involvement builds respect.*

Tip 93: Stay in Contact with Former Students and Professionals

K*eep in contact with young practicing professional artists. Ask questions about current trends in artistic careers. Adjust your curriculum to meet the interests and needs of the next generation.*

As I approached the end of this book, I knew I wanted to hear from the so-called hired young guns in art. Two of my past students have gone on to do great things. Below are their brief professional biographies and their responses to questions I asked them in thinking about their own art education.

Shannon Shea

In my second year of teaching, I had the pleasure of teaching a young man named Shannon Shea. Shannon attended Archbishop Shaw High School in Marrero, Louisiana. He created an awesome mascot creature for our Catholic boys' school. It was a muscle bound swamp fellow called "Gang Green" (an obvious play off the term *gangrene*, a scary condition and a mascot worthy of fear in this land of bayous)! He won my respect immediately with his work ethic and good humor. Shannon graduated college from California Institute of the Arts in 1982 and now works in the movie industry. He is a sculptor, a painter, a Screen Actors Guild puppeteer/performer, an animatronics project supervisor, and a production liaison. Let us just say that the student far surpassed the teacher!

When I asked Shannon recently to send me his resume, it took four full pages to list the movies with which he has been involved—big titles like *Spiderman 2, Terminator 3, Kill Bill, The Green Mile,*

Jurassic Park, Batman Returns ,Casino Royale and *The Pacific,* an HBO mini-series. He often has worked with KNBEFX Studio and Stan Winston Studio, which incidentally has the most interesting web site I have ever seen. You can see Shannon being interviewed on the *Once Upon a Time in Mexico* DVD. He and other artists explain the special effects they created for the movie. This can be found in the introduction under the title, "The Good, the Bad and the Gory." Very cool stuff! Shannon is now working on the greatly anticipated *Men in Black III* and with Rick Baker's studio.

Words from Shannon

I feel, not only as a working, professional artist, but as a human being, that society has put too much emphasis on computers. It has been said that we live in the "information age" and this progress should herald the way the industrial revolution did away with horse-drawn carriages and black smiths. Granted, we must make room for progress, but not at the expense of our humanity. I recall having an argument in a class at Cal Arts in 1980. The avant-garde college taught with the understanding that real Fine Art exploded after the invention of the camera. Before that time, "artists" were just human cameras capturing important religious/political figures, historical events, and slices of everyday life within the society where the artist flourished. I call that bunk. To say that Michelangelo was just a camera or that Caravaggio was just a human Xerox machine is insulting to those individuals who possessed talents that were exceptional even by today's standards.

So, I guess what I am saying is that from what I can see in most art classrooms (there are some exceptions like the "Mission Renaissance" programs here in Southern California), there is a rush to get students to explore abstract impressionism before the

fundamentals are learned. I recall that my experience started with a book by Jon Gnacy that I found in my house when I was a child. Inside were basic exercises that everyone sighs and rolls their eyes when they have to perform them: Spheres, Boxes, Cylinders, Cones, Shading, Perspective Exercises, Rendering Textures, etc. They seem boring at first but they are SO essential to building that incredibly strong foundation needed by a visual artist. Even if the individual is interested *only* in computer art, the necessity for understanding how to break a complex figure down into rudimentary shapes is important and an integral part of most 3-D modeling software. There must be an insistence in learning these essentials as well as COLOR THEORY. I *still* buy books that show examples of interesting color combinations just to expand my design sense. Most of us experience life in color and understanding how to put colors next to each other to achieve an effect. Organizing a color palette *before* beginning an art piece is something that they may overlook.

Now, I am going to throw a monkey wrench into the works. The last, most important aspect of art education is to get students *excited* about art. So many kids do not want to know about Flemish still life and trying to get them excited about Degas is a chore. Art History is *important*, believe me, I am not saying ignore it; what I am going to suggest is *expand* it. Art teachers need to break out of their texts, the gallery scenes, etc., and look for art that *connects* with kids. Comic Books, Animation Art, Lowbrow Artists like Todd Schorr and Shag, Skateboard Artists, Video Games, Graffiti Artists, art that kids can *connect* with and then show how classic art has *influenced* these artists. *Connect* instead of trying to work from cave art to Warhol. Why not work backwards from Disney to the Renaissance? For instance, few know that the design for SLEEPING BEAUTY was all inspired by Medieval

Art and design. Most of the sculptors I work with have taken inspiration from classical sculptors and what do we make all day long? MONSTERS. I do not know many kids that have walked through our studios that have not been entranced by someone modeling a monster out of clay

And, with all of the magazines, books, videos, and DVD'S and video out there featuring guys like RICK BAKER and STAN WINSTON, any teacher can have examples of how classical techniques still translate into today's pop art through this discipline. Another great example of work students can relate to is in the beginning of the movie SPIDERMAN 2. The artwork at the beginning is gouache paintings done by this guy: Alex Ross Art. Highly influenced by the masters and classically trained, he has found a niche for himself. His work is amazing and inspiring.

We need to show every generation why art is so important not just to the individual that produces it, but to our entire society, our entire civilization. Art defines us as human beings and without it, we will lose our humanity. The need for expression is what sets us apart from other mammals and we cannot afford to lose the ability to express through direct, physical means, not just with a computer program. Someone told me recently that art schools no longer teach illustration like the ones used so frequently in advertising about 40 years ago and now few know how to do it. That scares me. Just because we have chosen *not* to use paintings in our advertisements, does not mean that the technique is disposable. Every artist should have some knowledge of how to draw and paint from reality before they explore their emotions through abstract impressionism. Walk before you run.

I have said this before and I will say it again; your belief and encouragement of my meager abilities helped push me past the margins of my comfort and pursue a risky, creative and ultimately

successful career. I may not be the wealthiest man alive based on money, but I would not trade places with anyone else in the world. Every day I get to do some sort of creative work is a successful day and there are few days that I do not do *some* sort of creative work.

Kinzie Dudgeon Harvell

Kinzie Dudgeon Harvell came into my program in the tenth grade. Kinzie was a tall, energetic, honey blonde dynamo. Kinzie had confidence and easily admitted when her artwork did not satisfy her. She was not afraid to try difficult or new techniques. In fact, she approached all assignments with gusto. Her honesty was always welcomed. Kinzie stayed in my program for three years. On the last day of her senior year she came up to me, eye to eye and said, "Mrs. Johnt, I don't know when you plan on retiring, but if you will just wait five years, I'm coming back to take your place and teach." I just fell over laughing! What a wonderful idea! I replied to her, "I can't think of anything that would make me any happier than knowing that you want to be an art teacher and that you want to take my place."

Kinzie did go to college and she majored in art. I heard from her after she finished her student teaching. She was full of the excitement that comes with her first "fully responsible for everything" art teaching experience. I asked Kinzie three questions: 1. What project did you teach that is most special to you? 2. What circumstances frustrated you as a teacher and you know that you need to improve? 3. What are you most proud of happening in your class? Here is her reply.

Words From Kinzie

I organized and carried out an Empty Bowls Project. The project stems from a list of ideas that I have been making over the last year of community services projects that I want to incorporate into the curriculum. I know that when I was in high school the community and giving back were not a part of my everyday thoughts. The kids here are quite the same and I wanted them to realize that they can do little things to contribute to the well being of the community that pours so much into them. I want to make this an annual event in my own classroom as well as making sure that my student artists are aware of how they can use their creativity to inspire others to give back. Here is how the project went. Each student made a clay bowl, designed it, glazed it and fired it. They knew they were not going to keep it for themselves and that even inspired them more. We got the community involved and we sold tickets for a soup meal for $5.00 a meal. Many people donated more than the $5.00. We made $1,200.00 and donated it all to Second Harvest Food Bank. The local newspaper came and did wonderful front-page coverage of the event. I love teaching more than I thought I would. Yesterday was my last day and I have cried all day today. Luckily, many of my students have sent me e-mails and text messages. We have gotten pretty attached . . .

. . . Students who put their heads on their desks with no interest to do anything, yet expect to make an A frustrated me. I had teachers who ask for too many artistic favors. Other teachers who believe your class is just play time. I observed students who are fearful of 3Dimentional art projects. I saw students who will not try because they are afraid they will fail. I second-guessed myself when sending a student to the office. Gaining control of the classroom and deciding on different levels of discipline was difficult at first. How far should I push the students towards their

personal best and how much one-on-one teaching is necessary? How do I avoid showing favoritism? Keeping things clean all day is a big effort. When is being too casual and too sweet going too far? How to keep hyper-students busy after they finish their assignment is critical. Fully involving Special Education students takes extra planning. Including the community in the art curriculum is necessary if I want to do projects outside of the school setting. Designing a program that students want to line up and be a part of takes advanced planning. Incorporating more graphic-design, photography, and technology into the curriculum is a priority for me.

. . . Inspiring civic responsibility; students apologizing without being prompted; being able to model my faith without using words; students valuing my concern for them; developing dynamo organizational skills; encouraged students to do their very best; no one was injured; learned to estimate time needed for assignment completion; a parent telling me that her Special Needs child has blossomed in my class.

So there you have it! A touching, sharing of ideas between me, one of my first brilliant students who is in his forties, and a young thoughtful student teacher in her twenties. How fortunate for me to know both of these sincere and sensitive artists. By the way, Kinzie couldn't keep her promise to take my place after student teaching. Her life took other exciting turns. She married, earned a Masters of Art Education and is thrilled to be teaching art in Texas. (I retired earlier than expected and was delighted when my cousin, Renee Fowler Mc Neil, an outstanding art teacher in her own right, was available to take my position.)

By keeping in contact with former students, you will keep your ideas and inspirations fresh. The world moves in different rhythms from the one you orbit in daily life. Their observations broadens your view of the art world and *you don't want to be stuck teaching from an outdated view of the world.*

Tip 94: Become the Greatest Contribution to the Arts

Create yourself as a teacher who will be the reason a child comes to school every day. You will be your greatest contribution to the arts.

Recently we sold our home in south Alabama and moved on to new adventures and challenges. I spent most of my first year away from school analyzing just what an art teacher does then writing my observations in this book. During this time, I needed to transfer some things from storage, so I made a final trip back to Spanish Fort, Alabama, and the home where we had lived. *Homesick* would best describe my mood that day. Because Spanish Fort was not the town I taught in, I did not expect to run into a former student. I stopped at a curbside fruit and vegetable stand, when a former student I taught one year earlier, suddenly, completely covered me in a big, gangly puppy dog hug. "Mrs. Johnt! Mrs. Johnt! I can't believe it's you! Wow, I *missed* you!" he said convincingly. I was certainly surprised to see him here and the women he was working with thought the boy had lost his mind! I had taught this boy in his junior year; if all things had moved according to plan, he would have been graduated, but after a few moments, I discovered that he had dropped out of school halfway through his senior year. He told me there was a definite void in his daily school experience after I retired. I shared with him that I was writing an art teacher's book and I asked him to explain just why my class had such an effect on him.

He became very serious and he carefully chose his words. "It's not what you taught me, it was just *you*. I felt I belonged. Mrs.

Johnt, you didn't know that I was a big problem in most of my classes. In your class, I felt comfortable, at ease, and busy. I did not want you to be disappointed in me so I worked hard. You are why I came to school, along with liking my math teacher. Mrs. Johnt, we know I had average talent, but I looked forward to being a part of your class. You talked to me *every day* when you walked around the room. I am going to go back and get my GED diploma and when I get it, I will find you to show it to you!"

I was so touched. I believe he was sent to me that day. He is a bright boy and I know he will find his way. As I left the fruit stand, I had tears in my eyes and a lump in my throat the size of a potato. I waved good-by to him and I saw a grateful, big smile on his face in my rear view mirror. I was proud of my art-teaching career. These were years that I made a difference for some children and I was glad that I had chosen this career.

Driving away for home back north that evening, I recalled the final moments in my old classroom last year when I was all alone with the memories: I was turning off the computer after I checked my final grades. Looking up, I saw two cards taped to my computer room wall. I had not noticed them in years. They read, *"Mrs. Johnt is cool… and that's why we come to school."* They were made to go on the outside art room door facing the main hallway. These carefully cut and hand written calligraphy cards were a part of a door decorating competition for a school sponsored Halloween event several years earlier. I gently removed them and carefully put them on top of a packed box to go home with me. It was *the very last thing* I packed from my classroom and the most meaningful. They were more valuable to me than fine jewelry.

For new teachers, this is important to grasp: it won't be *what* you taught that will be most remembered by your students, it will be *the way you treated them* while you were opening their eyes to art.

Tip 95: Smile When Others Call You "Lucky"

*I*f you are a good art teacher, visitors to your program will think you are "lucky" to have such well rounded students. Agree with them and smile, although you know what it took to make your classes this way.

Be ready for this. People will think that you have been "lucky" to be assigned such nice students; "lucky" to have been assigned such hard working students; "lucky" to have hit the lottery and ended up with such unique and creative students; "lucky" to get polite and kind students and hardly any thugs; "lucky" to get such responsible students.

Only you and I know the *hard work, planning, discipline, consistency, open heart, and fat hearty laughter* it took to create this very special class environment.

Tips 96–100: Commit to Five

Thoughtfully consider your art program and commit to addressing five issues that you see as challenges to your teaching.

Now that you have carefully read the ninety-five tips and answered all of the Thought Provoking Questions honestly, go back, review, and choose five tips that you know will improve your art program, if you will just do them. Your five selections will be unlike anyone else's list. You are a teacher who is the culmination of both good and bad life and educational experiences. Only you can assess what you need to work on to make you a more successful teacher. It is never too late to break bad habits that are wearing you down. Dedicate a full year to five topics you can improve. If you need to write your own original commitments, do some of those, too. Make your first three commitments your biggest priority though. Draw a big fat red line though the ones that you accomplish! You do not need to share this list of five with anyone. It should be private. No supervisor need be involved in your improvement campaign. However, do note; your supervisor will see your improved teaching skills *if* you courageously chose the five points you most need to address.

Pull your sword soldier, start marching and be courageous. People are just people and we have frailties. We are all unique and we all are valuable, no matter what our quirky traits may be.

1.

2.

3.

4.

5.

A Final Reflection and Brief Personal History

My mother, Mildred Walker Hanson, was a talented and successful florist; she and her creative sister, Betty Walker Raley, owned a thriving business. They were very pretty women in their straight skirts and high heel pumps. I would spend a lot of time at their flower shop when I was in elementary school. I was allowed to cut Styrofoam scraps on the hot wire cutter. I played for *hours* in the flower trash pile where I had access to scrap wire, empty ribbon rolls, putty, ribbon scraps, florist foams, pins, forty different kinds of flowers on the wilted side of life, along with the artificial flowers. There was string and huge strong boxes that the roses were shipped in. There was colorful foil wrapping paper used to wrap live plants. I had access to four different types of scissors if I could sneak them away. There were buckets of sand to play in, and little green wooden picks with delicate wires to connect and anchor. I could go grab a pile of little cards with their little colorful designs for birthdays, deaths, births, and hospital visits. If I were quiet, I could go inside and watch Mama, Betty, and the other ladies design the massive funeral sprays, then change gears to make a small, delicate baby arrangement, and then to a tiny corsage with

an exotic orchid. I listened to them as they tried to solve a design problem. I watched as the local citizens came in to chat about local news and explain what kind of arrangements they needed for their bridge club or the Rotary Banquet. I could go into the cooler, see the fresh, unopened flowers, and then skip right out to see the seasonal dried arrangements. Mama and Betty allowed me to go along with them when they placed the street window displays for local merchants during the Christmas season.

Those rich and interesting textures, sights, smells, words, tools, colors and many fascinating adults bombarded me by the time I was 10 years old. That year, Ms. Yarborough, my favorite teacher, wanted her sixth grade students to do an art project. This was a *very* big deal to get to do an art project in school! There were no art teachers in these small town schools. My mother came up with a *fabulous* project where we made birdcages out of chenille wire and Styrofoam tops and bottoms. We filled them with artificial flowers, ribbons, and other fun elements left over from the florist business.

My mother and the school system spent little on my personal art supplies, but what a rich art world I lived in.

Not all of your students will have these kinds of experiences. I have asked my students to discuss their exposure to art, art books, creating art, art that hangs in their homes, or artists they know. I was naïve about what their art experiences had been. There are high school students who do not have magazines or *any* kind of books in their houses, mobile homes, or apartments. They have never looked at a beautiful art history book before. On the walls of their homes hang school photos only. Extra money is spent on better shoes, not art supplies. No one makes a living in their families by doing artistic things. Many have never been more than 60 miles away from their hometown and have not visited an

art exhibit. They have never heard adults speak about what kind of art they like or do not like. In other words, they come from environments where visually interesting imagery is not valued, or not understood by the adults.

I did not want to be a schoolteacher when I was 18 years old. I wanted to do something unique and exciting. I was influenced by the tired old saying, "Those who can, do. Those who can't, teach." Unfortunately, the interest tests given at the University of Alabama pointed sky high to my inclinations towards teaching so I decided to look over the major requirements and I finally found something that grabbed my attention. In choosing art education as my major, I would not have to take any more advanced level math or upper level foreign languages. Not very noble, was it? In the end, though, it does not matter *how* I came to my decision at age 18. What does matter is that I did choose to be a teacher.

That was 23 teaching years ago. I cannot believe the changes in art techniques and the importance that machines now have. It is just as remarkable to me what has not changed at all. Motivation, discipline, classroom management, ordering, storing supplies and budgeting still have to be done. Having a good relationship with the faculty, staff and parents have remained the same. Expecting and getting high levels of thinking from the students never changes. Here are a few changes in the teaching world within the lifetimes of my grandparents:

My great-grandfather, John Dennis Forte (who I called Granddaddy Forte), was the Monroe County Superintendent of Education in Monroe County, Alabama in 1900. Harper Lee lives there and based her famous novel, *To Kill a Mockingbird* in this county. Granddaddy Forte drove a horse and buggy to *every* teacher's home in the county and paid their wages in the silver

coins he kept in a large sack. He spent the night on the road with a different teacher's family. He bragged that the money always balanced to the penny at the end of the deliveries. Granddaddy looked an awful lot like Mark Twain. Here is a picture of my little cousin, Tracy Walker, with Granddaddy Forte and me when he was 94 years old and I was in elementary school. More on this old teacher's life in a moment.

Marlene Nall, Tracy Walker, and John Dennis Forte, 1965

Granddaddy Forte's oldest daughter, Margaret Forte Walker, my maternal grandmother (who I am named after) was a schoolteacher. She taught at several rural Alabama schools in the 1920's and 1930's.

Can you *imagine* teaching in buildings like these! I doubt that you will have to bring in coal and fire wood to heat your room. Still, there is something nostalgic about not having supervisors, programmed electric bells, and endless state and federal rules and regulations to document and follow. In her home, my mom displays Margaret's brass hand bell she used to call the students to class.

My paternal grandmother, Myrtice Wise Nall, taught school, also. Now this is a story: Grandmother was one of sixteen children by the same mother and father. Some of the older children took turns going to high school in Monroeville, Alabama. The family farm was in McCullough, Alabama so the teens took turns living in a boarding house near the school. They lived with their childhood home-schooling teacher. The older children were expected to help pay the costs for the younger children to go to high school and to college. This was during the Great Depression, but their parents were adamant that the children be educated. All of the children did manage to graduate from high school and on to business school from there. *Ten* of the children went on to college.

Grandmother Nall taught school with a two-year college degree from Troy University until the early 1960s when a four-year teaching degree was required. She went back to college during the summers to get her four-year degree. When she graduated in 1962 from Troy University, six of her *nine* (all grown) children came to the ceremony. She raised nine very fine children and taught school most of the time for all of those years. Can you imagine how organized she had to be and how she delegated responsibilities to her children while maintaining a teaching career? We adored her.

Children Louise, Myra, Olen, Grandmother Nall in cap and
gown, Wilda, Aurora, and Emmanette at Myrtice Wise Nall's
college graduation ceremony. Not present were sons Marlin,
Shelby, and Adrian.

Let me return to a final story about Granddaddy Forte. After
he died in the early 1960's, his granddaughter found two, one
foot long paper scrolls that he had made as a yearly diary. He
begins by describing his early life in the 1870's in Alabama, just a
few years after the Civil War. He described illnesses treated with
herbs and clay. He described life at Rikard's Mill, the community
gristmill, built by his grandfather, Jake Rikard (the mill in now on
the National Historic Registry). He described his teaching years
and important events in his life. When I first saw these scrolls, I
literally lost my breath when he described John Glenn circling the
earth in a spaceship. His quaint, flowing, formal dipped penned
handwriting had changed as he aged. His handwriting was shaky
and awkward as he wrote his final entry on April 3, 1964: "In my
94th year I look back and see how good Mother, Father, Brothers,
Sisters, Wife, and Children have been to me, but the loving God
was back of all this loving kindness."

I am sure you see that your personal life will throw you curves as you teach and that technology and teacher requirements will certainly change. I wanted to describe for you a broader picture of your career. How are you going to influence the *thousands* of students that you will teach? What legacy do *you* want to leave with your students? I have no doubt of the legacy I wanted to leave; I wanted to contribute to the development of thoughtful, caring, curious and interesting citizens of the world. And yes, your students will remember your loving approach to life and your kindness towards them. I have wonderful thoughts about my teaching career, I have a clear conscience about how I handled my students, and I take pride in how I taught them. I can now enjoy my free time with my husband, family, friends, dogs and my garden. I can finally get around to all those paintings and projects I wanted to do years ago. Now I can travel and see interesting places during the fall and winter teaching months. I have left you with my best observations and advice while I am young enough to remember it all.

Now get going, and take my place in the classroom. Make me proud!

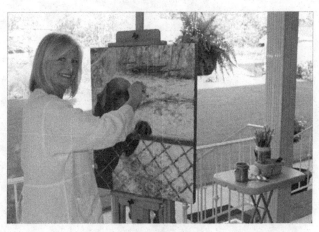

Marlene Johnt enjoying her retirement years